9·35

H WEIR

embroidery ⌐ from

palestine

THE BRITISH MUSEUM PRESS

Dedicated to the Arab village women of Palestine
for their creativity and courage.

© 2006 The Trustees of the British Museum

First published in 2006 by The British Museum Press
A division of The British Museum Company Ltd
38 Russell Square, London WC1B 3QQ

www.britishmuseum.co.uk

Shelagh Weir has asserted the right to be identified as the author of this work

A catalogue record for this book is available from the British Library

ISBN-13: 978-0-7141-2573-2

ISBN-10: 0-7141-2573-3

Designer: Paul Welti
Map: Technical Art Services
Printed by C&C Offset, China

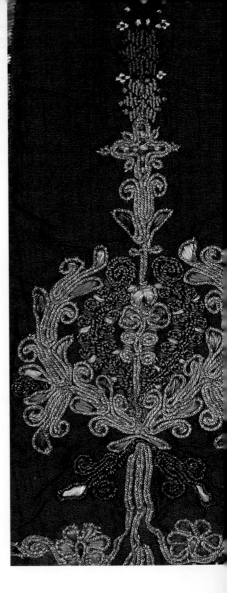

COVER: Detail from the chest of a Bethlehem dress. (See pages 78–81)
INSIDE COVER: Patchwork from a Galilee coat. (See pages 28–9)
PREVIOUS PAGES: Detail from the chest panel of a dress from Beit 'Ummar between
Bethlehem and Hebron. (See pages 43-5)
THESE PAGES: Details from the skirt of a Bethlehem dress. (See pages 78–81)

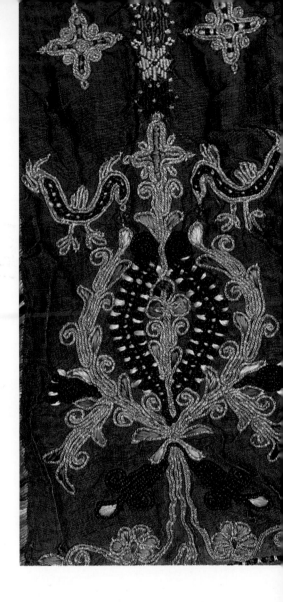

contents

Opposite are details from a selection of textiles
TOP: Dress from south-west coastal plain. (see pages 56-7)
LEFT: Veil from Falujeh, southern coastal plain. (see pages 58-9)
RIGHT: Veil from Hebron Hills. (see pages 66-7)
BELOW: Dress from south-west coastal plain. (see pages 53-5)

introduction

The beautiful embroidery and appliqué illustrated in this book was made by the Arab women of rural Palestine between the early nineteenth century and the mid-twentieth century. This period includes the last of four centuries of Ottoman rule, which ended after the First World War, and the three decades of British Mandate rule, beginning in 1918 and ending with the establishment of the State of Israel in northern, western and southern Palestine in 1948.

During this time, the population of Palestine was, as it had been for centuries,

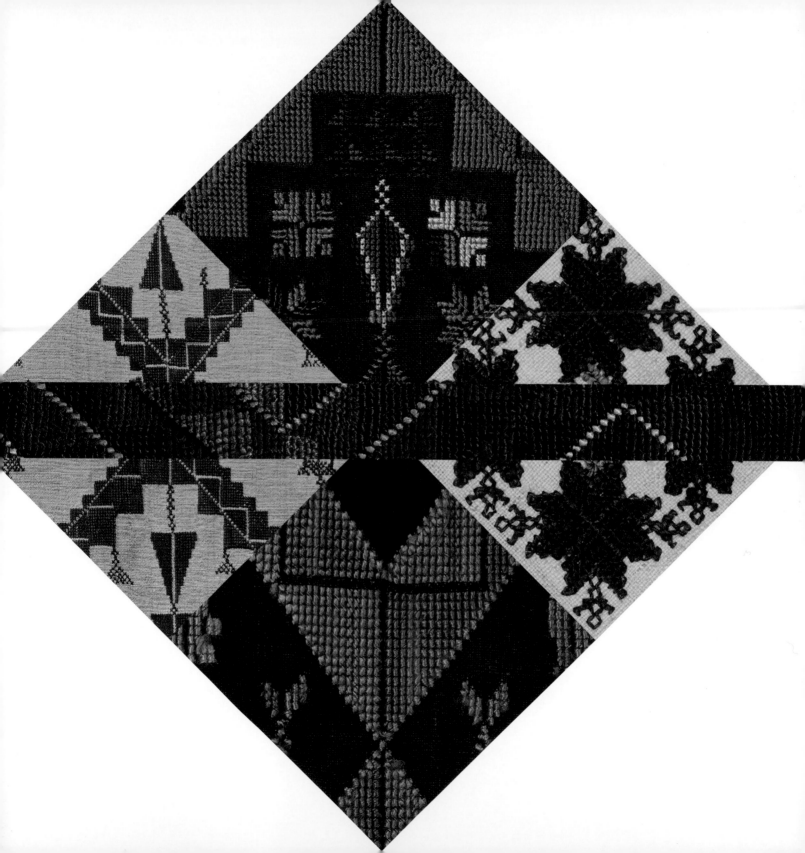

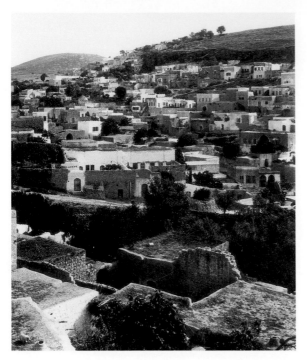

The village of Safed in Galilee, British Mandate period.

predominantly Arab and Muslim with a minority of Christian Arabs and Jews. The majority of the Arabs lived in over eight hundred villages scattered throughout the coastal plain and in the hills to the north and east; they made their living from farming, trading and labouring. It is in these villages that the extraordinary textile art shown here developed and flourished. The rest lived in the towns – Jerusalem, Jaffa, Haifa, Hebron, Nablus, Mejdel, Gaza, Lydda, Ramleh, Nazareth and Tiberias – and engaged in various urban trades and professions. Townspeople generally followed the dress fashions of the Turkish or British ruling classes. The remainder of the Palestinian Arabs were nomadic or semi-nomadic bedouin who lived in the deserts and depended mainly on animal-herding. The dress of the bedouin women was similar to that of the more prosperous villagers, whom they emulated, but had its own distinctive styles, colour schemes and embroidery. For reasons of space, only village embroidery is considered here.

ORIGINS AND INFLUENCES

We do not know when the village women of Palestine began to adorn their garments with embroidery and patchwork. Early travellers recorded little and the simple conditions of Palestinian village life were not conducive to the preservation of old garments: once they wore out, they were discarded. The earliest surviving examples date back only to the beginning or middle of the nineteenth century. Some of these were collected by members of Christian missionary societies for use in fundraising exhibitions back home, and later found their way into museums, including the British Museum. Other old Palestinian garments were brought back to Europe as souvenirs by people who visited 'the Holy Land' for religious or professional reasons. Perhaps the most famous such foreign collector is the pre-Raphaelite artist William Holman Hunt, who took some beautiful dresses home to depict in his paintings. These early pieces show that by the middle of the nineteenth century embroidery was already a highly developed art, at least in some villages.

Palestinian costume and embroidery were subject to diverse influences. Major trade and travel routes passed through Palestine, connecting it by land and sea to neighbouring countries of the eastern Mediterranean, and further afield. A variety of enticing textiles, mainly from Syria, Turkey and Europe, therefore found their way into the shops of the main towns where the people of the surrounding villages marketed their produce and bought their supplies. Many foreigners went to Palestine as tourists or officials, or as pilgrims to its Muslim, Christian or Jewish holy places, all wearing their own traditional costumes and often bearing cloth and clothing to present as gifts or to sell to finance their sojourns. Some female visitors intermarried with local men and probably showed local women their own techniques and patterns. This could account for the similarities between certain common Palestinian embroidery patterns, such as tree motifs, and those of rural Syria, Turkey and Greece. New ideas were also imported by Christian missionaries from England, Germany and America who ran embroidery classes, introduced new patterns and commissioned embroidered tablecloths, napkins and other articles from local women in order to give them an income and to support their evangelical, educational and welfare work in Palestine. Some of this activity continues today, for example by the Mennonites. Another major influence on Palestinian embroidery from the 1930s onwards was the introduction of *perlé* (mercerized) cotton threads made by the

French embroidery company, Dolfus Mieg et Cie (DMC), which were marketed with pattern books. Women were also surrounded by indigenous sources of artistic inspiration: the ornaments on archaeological remains and architecture; oriental rugs for sale in markets; the uniforms of Ottoman and British soldiers and guards; and the ornate vestments of the Christian clergy. While the village women of Palestine borrowed ideas from all such sources, however, their art was fundamentally sustained by their own customs and values.

LEARNING EMBROIDERY

Embroidery was an exclusively female art and was passed from generation to generation within families. Most girls were expected to learn how to embroider and as soon as a girl was old enough to wield a needle – around the age of six or seven – she was given a scrap of cloth and a few threads to practise with, and embroidery to copy. She was taught the techniques and patterns of her village by her elders. This was considered an important educational process which involved learning both a physical skill and a complex system of visual communication. 'Embroidery was like our school', an old woman remembered, looking back to her childhood before village schools opened. And another explained, 'Embroidery was like a language, and some girls just couldn't grasp it.' A girl not only had to learn how to execute a variety of stitches and to build up patterns, but also had to become familiar with the repertoire of motifs used in her village, and

Girl embroidering, probably British Mandate period.

to absorb the rich vocabulary and grammar of embroidery.

Every stitch, motif, and even part of a motif, had a name which could be peculiar to a village, or group of villages, or shared more widely. Stitches and motifs were named after familiar things in the agricultural and social world, though they did not necessarily resemble them. The inspiration for the stitches called 'ears of corn' or 'eye of a chick', or the motifs named 'cypress trees', 'palms' and 'birds' in southern Palestinian embroidery is obvious, but this is not the case for the triangular motifs called 'apples', or the geometric, politically inspired patterns known as 'the tents of the Pasha' or 'Sadat and Begin'. All

such names functioned mainly as labels which enabled women to discuss and commission their work and had no profound symbolic meaning.

Girls also had to learn which stitches to use for different parts of a garment (the seams, hems, and so on) and how to arrange the embroidery. Each garment had an embroidery structure, and motifs had to be combined in particular ways in its different parts according to the customs of each village. All this had meaning. While villagers shared a common embroidery 'grammar', there were dialectal variations which self-consciously expressed village identities. They also reflected changes in fashion within villages. What was 'correct' for one generation became 'wrong' for the next, as new stitches or motifs were introduced within the overall framework.

THE WEDDING TROUSSEAU

Once a girl became competent with a needle and thread, she began preparing articles for her wedding trousseau. This was appropriately called her *jihaz*, meaning 'equipment', and it did indeed equip her for her future status as a married woman. Both the bride's and the groom's families contributed to the trousseau. The bride's contribution included simple, unadorned dresses and veils for everyday working life in the home, orchards and fields, and richly embroidered garments for wearing at celebrations such as weddings, circumcision ceremonies, religious festivals and pilgrimages, or for outings to town. These items were all

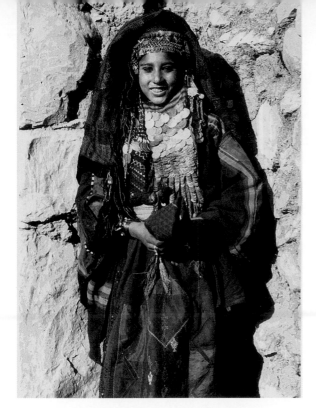

Bride in Qubeibeh ibn ʿAwad west of Hebron, 1932–3.

Embroidery was always done on pieces of fabric cut to shape for sleeves, chest panels, side panels, and so on, then sewn together to make complete garments after the decoration was completed. The girl's eventual measurements were gauged by her mother's, so that by the time she married (usually in her teens) her dresses would hopefully fit her. The preparation of the trousseau could take months, or years if money was short, because embroidery silks were expensive and were bought piecemeal as people could afford them. Different batches of silk were often not an exact match, which is why varying shades of the same colours are sometimes found on the same dress, often creating beautiful effects. Some dresses appear to have been worked by different hands. This might be because a girl's technique had improved over the course of time, or because her marriage was arranged at short notice and the women in her family had had to rally round to help finish her dresses in time for her imminent wedding. A nostalgic wedding song from the former village of Beit Dajan near Jaffa recalls the long and companionable process of preparing the trousseau:

paid for by the girl's father or guardian. He also provided her with her silver dowry jewellery and with the coins she would attach to her married-woman's bonnet, which were considered her share of the 'brideprice' from the groom. The groom's contribution to the trousseau, called the *kisweh*, comprised luxury items bought from textile merchants in the towns and embroidered panels or garments commissioned from professional embroiderers. Both categories of trousseau constituted hierarchical sets, within which garments were ranked in order of importance and value. There was, for example, a 'best' dress, a second best and so on, in both the bride's and the groom's contributions to the trousseau.

> *We embroidered the side panels for such a*
> *long time!*
> *Remember Halimeh, when we were pals?*
> *We embroidered the chest panels for such a*
> *long time!*
> *Remember Halimeh, when we were girls?*

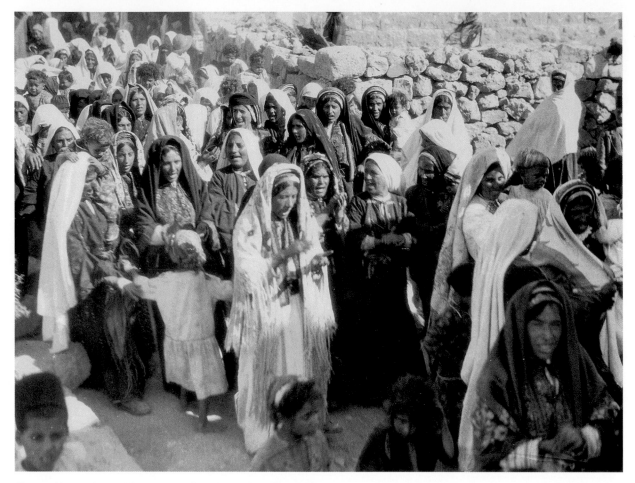

Women taking part in a wedding procession, Beitunia near Ramallah, 1938/9.

THE WEDDING

Girls wore their trousseau garments for the first time at their weddings. Wedding ceremonies typically lasted a week. At the beginning of the week the bride was escorted by her male relatives to the groom's home on camel or donkey-back, entirely concealed by cloaks and veils. The marriage was ideally consummated that night, and during the following days the bride received a succession of female friends and relatives in her new home and showed off her trousseau, sometimes changing into a different dress every day. Then at the end of the week a ceremonial procession took place, called the 'going out to the well', which welcomed the bride back into society after her period of ritual seclusion and celebrated her transformation from unmarried

virgin to married woman. In contrast to the first procession, when the bride was an anonymous, passive bundle conveyed by men, for this flamboyant and exclusively female event she donned her most splendid trousseau garments and all her silver dowry jewellery. On this occasion she walked amongst a crowd of singing and ululating women, all dressed in their best with their silver jangling, to fetch water from the village well. Another Beit Dajan wedding song expresses the jubilation of this occasion:

> *Oh daughters of the wedding, trail your*
> *jillayehs*
> *A wedding is here again, may it happen to*
> *your families!*

The *jillayeh* was the finest dress that a bride prepared for her trousseau and which she usually wore for the 'going out to the well' ceremony.

After marriage women continued to embroider new garments to replace those which wore out or became unfashionable. They often carried their fabrics and sewing materials around with them and snatched opportunities to add a few more stitches while socializing, waiting at the well, or during slack times in the orchards or fields. A few girls who showed special talent and inclination, and whose families could release them from work, took up dressmaking and embroidery professionally, and sometimes remained unmarried because they could support themselves from their work.

THE ART AND LANGUAGE OF EMBROIDERY

Women applied strict technical and aesthetic standards to their embroidery. When I invited a group of women to comment on a selection of dresses, they weighed their merits and faults as earnestly as any art critic discussing an Old Master. Women who were careless in planning or executing their designs, who used the 'wrong' shades for their village, or skimped on fabric, thread or cord, were criticized, whilst those who did neat, well-planned work and used the highest quality materials, were admired and praised. Expert embroiderers were such connoisseurs that, when shown old dresses, they could sometimes identify the work of individual embroiderers from their own villages – and did not hesitate to criticize it. While examining a dress on which a repeat pattern had come out wrong, one woman exclaimed, 'How stupid of Fatimah to use that expensive thread and not count her stitches.' Another woman remarked about a different dress, 'How foolish this girl was to waste her time doing such intricate embroidery using shoddy threads.' Women who skilfully incorporated new ideas into their work, and especially wealthy, socially superior women, who were often fashion leaders, were particularly admired and imitated. Women were therefore always on the lookout for new ideas in order to gain prestige, especially those who embroidered for a living, since innovations could attract extra custom. Each of these factors, plus the influence of textile merchants who had a detailed knowledge of their clients'

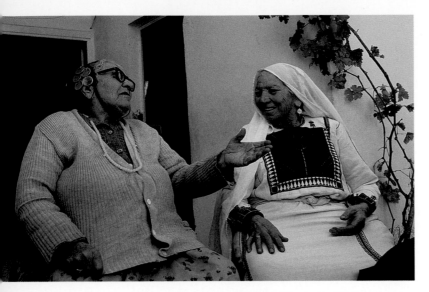

Halimeh and Ruqiyeh, the daughters of the shaykh of Beit Dajan near Jaffa. Hussein refugee camp, Amman, Jordan, 1974.

At the same time they assessed the work of other villages objectively, and if it equalled or bettered their own standards of excellence, or contained novel ideas, they copied those elements they admired – though always adapting them so as to maintain the distinctive features of their own village. This is how embroidery customs and designs spread within southern Palestine, especially after roads and buses were introduced during the British Mandate period and village women began mixing more widely. Women's aesthetic judgements were also linked to their generation. What was deemed beautiful and correct by an older woman was invariably that which had been fashionable in the heyday of her youth, when she was a young bride and enthusiastically kept up with the latest trends. Dress also reflected women's marital status and age. The lavishly embroidered and patched trousseau garments which a girl was entitled to wear only after her wedding proclaimed that she was a married woman. More specifically, the predominantly red embroidery, which was symbolically associated with the blood of virginity, menstruation and parturition, reflected the fact that she was of prime childbearing age; when women reached the menopause their embroidery became more restrained. Bright, rich embroidery was also an expression of normality and joy and was covered, turned inside out, or dyed blue during periods of mourning, and rent to express grief.

tastes and who stocked new products they knew would tempt them, caused fashions in garments, fabrics and embroidery to change through time.

Village women's costume, and especially its embroidery, constituted a quintessentially female language, barely understood by men, that proclaimed key aspects of women's social identity. Their overall attire announced that they were peasants as distinct from bedouin or townswomen, and which region of Palestine they came from. And the specific patterns and colours of their embroidery and patchwork revealed to those with local knowledge which group of villages, or even individual village, they belonged to. Women took enormous pride in the embroidery of their own village, which they often boasted was 'the best' of their area.

Extravagant embroidery and patchwork, and abundant garments, flaunted wealth.

Materials were expensive and a heavily embroidered dress or veil thus implied a substantial investment of time and labour and reflected the economic circumstances of the fathers and husbands who usually footed the bills. The function of embroidery as a form of conspicuous display was facilitated by the fact that trousseau dresses were differentiated and ranked according to their fabrics, how heavily they were embroidered and by specific embroidery patterns after which they were named. This enabled the wealthier villagers to show off just how many different garments they had been able to afford. These status connotations are reflected in another Beit Dajan wedding song, which equates the two best dresses in the trousseau with prominent men (village elders) and with the two-storeyed houses with arcaded balconies which wealthy families began to build from the late 1920s onwards, when orange-growing and wage labour were improving village fortunes:

> *How lovely to hear the compliments when we*
> *wore our jillayehs!*
> *We the elders are in our upper rooms*
> *How lovely to hear the compliments when we*
> *wore our malak dresses!*
> *We the elders are beneath our arches.*

As mentioned above, the *jillayeh* was the best dress which the bride made for her trousseau. The *malak* or 'royal' dress was the best dress which the groom contributed to the trousseau and was commissioned from professional embroiderers in Bethlehem or Beit Jala, or from those working elsewhere who emulated their work.

MATERIALS

Most village women's garments were made from cottons or linens woven on simple treadle looms by professional male weavers in the towns. These fabrics were either left their natural colour or were dyed different shades of blue using indigo – the most expensive being the darkest because it took several dye baths to achieve deep shades. Women classified these contrasting colours as 'white' and 'dark', meaning 'black'. The great advantage of these hand-woven textiles, which helps account for their survival long after machine-made cloth became available, was their open weave. This enabled embroiderers to plan their overall designs and individual motifs by counting threads and was particularly important for cross stitch, the main stitch of southern Palestine. This ideally covered a maximum of two warp and two weft threads, and each stitch was supposed to be so neat that it looked like a blob rather than a cross.

Garments were not tailored or particularly shaped to the body, their principal purposes being to preserve a woman's modesty and to display aspects of her social identity. The pieces for everyday garments were sewn together, edge to edge, with simple running, zigzag or herringbone stitches. Dresses and coats were reinforced with facings inside openings and with shoulder and chest patches to prevent wear by

silver ornaments; they were also reinforced around hems to prevent them fraying when they brushed the ground. It seems reasonable to assume that decorative embroidery and appliqué originally evolved from this functional stitching and protective patchwork and binding.

Festive garments were either made from the same plain cottons and linens as everyday dresses, or from more sumptuous fabrics containing silk yarn; these were woven in the major weaving centres of Palestine (Mejdel, Gaza, Bethlehem and Beit Jala), or imported from the famous textile centres of Syria (Homs, Aleppo and Damascus). The floss silk and the silk and metallic cords used in older Palestinian embroidery also came from Syria. The silk came from Mount Lebanon or from imported cocoons and was processed and dyed in Homs and Damascus with kermes compounds (which gave shades of red, orange and yellow). It was sold in skeins which women wound onto small wooden spools and twisted into threads of the required thickness as they worked. Metallic cords were produced in Aleppo and Homs. Aniline-dyed silks were introduced into Syria and Palestine in the late nineteenth or early twentieth centuries, when small touches of brilliant pinks and greens began to appear among the predominant reds of Palestinian embroidery. They were widely adopted from the 1920s onwards, eventually supplanting silks coloured with natural dyes.

From the 1930s the beautiful floss silks, with their lustrous sheen, were gradually superseded by mercerized cotton threads made by DMC.

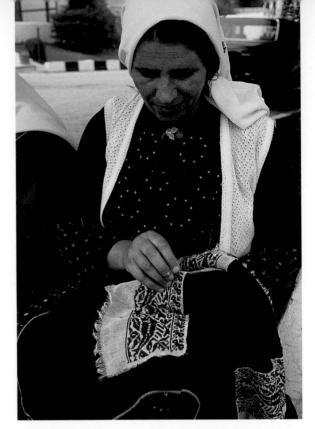

Woman embroidering in a refugee camp, Amman, Jordan, 1987. She is using mercerized cotton thread, and waste canvas on a synthetic fabric.

This new product had a major effect on Palestinian costume and embroidery. The threads were sold with waste embroidery canvas, which made it easier to embroider on imported fabrics with tight weaves and eventually encouraged a wider use of velvets, rayons and other synthetics. These new products also led to radical changes in embroidery as women eagerly copied new motifs from the DMC and other pattern books which appeared on the market at this time. Since DMC threads were produced in a wide range of unchanging colours and shades, each with its own number, a greater variety and

consistency of embroidery colours began to be used; this signalled the end of the beautiful gradations of shade sometimes found on dresses embroidered with the more variable floss silks. DMC threads also provided villagers with a more precise way of classifying their embroidery and of differentiating it from others. Pedlars who circulated the villages selling embroidery materials were well aware of this and made sure they carried the shades they knew were used in each village. These distinctions were maintained for decades, even among refugees. At the end of the 1980s a shopkeeper I met in Amman in Jordan still knew which number of red DMC thread to give a customer once she told him her natal village.

EMBROIDERY AND PATCHWORK FROM GALILEE

There were two major styles of female dress and ornamentation in village Palestine during the period considered in this book: that of the Galilee hills in northern Palestine, and that of southern Palestine.

The village women of Galilee wore a short-sleeved, calf-length coat of indigo or russet-coloured cotton, worn over a white tunic and ankle-length white or blue cotton trousers. Around their waists they wound patterned girdles and on their heads they wore coin-encrusted bonnets covered by dark silk veils, or later, scarves bound with brocade headbands.

The coats women prepared for their trousseaus and special occasions were heavily embellished from the waist to the hem with stitched embroidery and patchwork. Trouser legs were also embroidered. A greater variety of embroidery stitches was used in Galilee than in southern Palestine: satin stitch, running stitch, cross stitch, hem stitch and drawn-thread work. The embroidery was predominantly red, as elsewhere, with touches of other colours. Geometric motifs including diamonds, triangles, rectangles and chevrons were employed, and some coats were also ornamented with a small, repeated floral motif. These patterns were arranged in many different ways so as to give an impression of great variety.

The festive coats of Galilee were also ornamented with bold patches of red, green and yellow taffeta, or with panels or patchwork made from brilliantly coloured striped or ikat-patterned satin. Patches were rectangular or diamond-shaped, or were cut and slashed to make striking irregular forms, and were attached to the sleeves and front of the coat and sometimes also the back. Coats were apparently intended to be reversible, so that when they were worn inside out the stitches by which they were sewn to the fabric formed intriguing patterns on the outer surface, and the patches could be tantalizingly glimpsed when the coat flapped open. An English cleric, Canon Tristram, observed one of these coats in a village north of Acre in the early 1860s: 'This robe was plain patched or embroidered in most fantastic and grotesque shapes, the triumph of El Bussah milliners being evidently to bring together in contrast as many colours as

possible' (Tristram, 1865, p.68). Such garments appear to have been worn throughout Galilee in the first half of the nineteenth century, but were gradually replaced by Turkish-style garments made from Syrian cottons and satins and had gone out fashion by the early twentieth century. Unfortunately, this makes it impossible to delineate the main regional styles of costume and embroidery which once existed in Galilee, or to understand their symbolism, as it is possible to do for southern Palestine.

EMBROIDERY AND PATCHWORK FROM SOUTHERN PALESTINE

We know more about the traditional costumes of the rest of Palestine because they continued to be worn, in various transformations, throughout the twentieth century. The women of the villages around Tulkarm and Nablus did not embroider their costumes, either because they were too busy with agriculture, or because they had insufficient disposable income, although they did sometimes ornament them with appliqué patches or inserts. However, south of that region, on both the coastal plain of the Mediterranean and in the hills to the east, there was a great diversity of embroidery and appliqué work.

The women of central and southern Palestine wore ankle-length dresses with long sleeves, either tight or triangular, coloured sashes similar to those of Galilee, and flowing white veils, which they draped over bonnets sewn with dowry coins. In most areas only dark blue dresses of cotton or linen were worn, but in

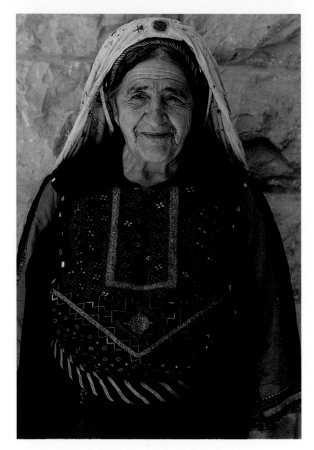

Woman in Ramallah, 1979. Her chest square is decorated with cross-stitch embroidery and gilt-cord couching, and her sleeves have taffeta inset panels with couched cuffs.

some villages, mainly in the Jaffa and Ramallah areas, women's trousseaus contained white as well as 'dark' dresses. This helped differentiate the dresses in each trousseau by colour as well as embroidery. In south-west Palestine, in addition to dresses of plain blue fabric, some were made from a distinctive navy-blue cotton with magenta or green silk stripes at the selvedge, which was still being woven in Gaza in the 1960s by refugees from Mejdel.

Until the early twentieth century the above styles of southern Palestinian dress co-existed, in some areas, with a kind of coat-dress with short sleeves and an opening from hem to waist, which either flapped open to reveal the long white shift worn beneath, or was held together with little tasselled and beaded ties. In some villages this opening, with its eye-catching fastenings and patchwork borders, was an explicit female sexual symbol. Partly for that reason, and partly because of a longing for renewal and change after the hardships of the First World War, when many village men were conscripted into the Turkish army and many others succumbed to the subsequent influenza pandemic, this garment went out of fashion in the 1920s.

Dresses were embroidered in symmetrical panels on the chest, sleeves, sides and lower back, according to the style of each region and group of villages. Within this set structure, particular parts and motifs were of differing significance. For example, the identity of Ramallah and the surrounding villages was symbolized by the distinctive 'palm leaf' pattern invariably found in the rectangular panel of embroidery on the back of the skirt. In Beit Dajan, on the other hand, certain motifs in these panels were used to name and rank dresses within the trousseau, and (until fashions changed in the 1930s) village identity was indicated by patterns called 'pockets and cypress trees' on the sides of skirts. The embroidery on veils was either distributed in narrow bands along the edges, or in large motifs on the main body of the veil, also according to the custom of the village or region. Bonnets and cushion covers were likewise embroidered in different ways according to region and village.

As in Galilee, the predominant colour of southern Palestinian embroidery during the period considered was red, enlivened with touches of other colours. The main stitch used to create patterns was cross stitch and other stitches such as satin stitch, herringbone and running stitch were used for binding hems, joining seams and attaching decorative panels

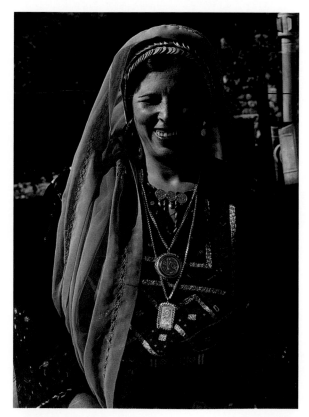

Ramallah woman, 1987.

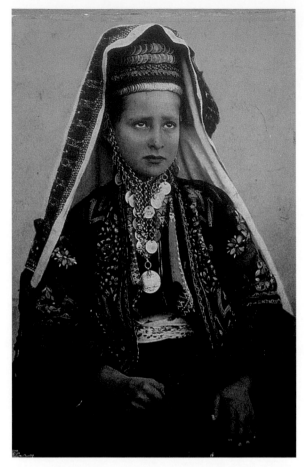

Girl from the Bethlehem area dressed as a bride, 19th century.

due to the influence of copybooks, and many of the older, more abstract patterns disappeared.

The most important and expensive trousseau dresses of southern Palestine were additionally embellished with patches, inserts and trimmings made from the same taffetas and satins as those used on Galilean coats. Patches of red and yellow striped satin were sewn onto the yokes of coat-dresses and dresses, and sometimes onto the front of the skirt. And panels of red, green, orange or yellow taffeta were applied to the chests and skirt-fronts of certain dresses, or inserted in their sleeves or sides; taffeta was also used to edge and patch hems and cuffs. Some chest panels were also made from overlapping layers of green, red and yellow taffeta with zigzag edges (*tishrimeh*). In contrast to thread embroidery, which was mostly done by women for themselves or their families, it was customary for these luxury materials to be attached to dresses by professional embroiderers. This was especially so in Bethlehem, where the idea for this kind of embellishment may well have originated, and where women specialized in this work.

BETHLEHEM-STYLE COUCHING

At some time before the middle of the nineteenth century, a strikingly different method of embellishing garments – couching – developed in Bethlehem and nearby villages. This was influenced by the cord and frogging which decorated the uniforms of Ottoman officials and soldiers, and by the flamboyant embroidery on

or patches of taffeta or satin. The embroidery patterns on dresses from the nineteenth and early twentieth centuries are mainly geometric and are variations on a few basic forms, especially triangles, chevrons, rosettes, feathered shapes and trees. Some representational motifs such as birds, flowers and urns are also found on these older dresses and are probably of European origin. The use of such motifs increased from the 1930s onwards

church vestments. One Christian Arab woman told me; 'When I went to church on Sundays, I used to gaze at the priests' robes and memorize the designs, then go home and copy them.'

In contrast to most cross-stitch embroidery, couching (like appliqué) was a commercial enterprise. In many villages of southern Palestine, the groom was expected to provide panels of couched embroidery as his contribution to the bridal trousseau, and these were commissioned from specialists who worked mainly in the Bethlehem area. From the late 1920s professional embroiderers in Beit Dajan and other villages near Jaffa also began to do couching, inspired by a Bethlehem embroiderer who used to visit her family's orange groves there.

The principal garments embroidered with couching were dresses, jackets (worn only in the cool hills), and the distinctive fez-shaped hats of the Bethlehem area. Couching was executed in silk, gilt or silver cord which was twisted into intricate curvilinear and floral patterns and sewn directly onto jackets of broadcloth or velvet, onto taffeta or velvet panels for attaching to dresses, or directly onto the dress fabrics. Usually the couched cords were framed or filled with herringbone, satin and other stitches in multicoloured floss silk threads.

The most spectacular examples of this work were applied to the taffeta chest panels and the sleeve and skirt inserts for the *malak* dress and other dresses which the groom contributed to the trousseau. Early examples were lightly embroidered in cross stitch, but from the second half of the nineteenth century, as people of

certain families and villages became more prosperous, these panels were increasingly heavily decorated; the most expensive varieties of chest panel became so densely embroidered that the background taffeta was entirely concealed. During the 1930s and 1940s Bethlehem-style embroidery became popular throughout southern Palestine and the trousseaus of most villages included some garments or panels ornamented with couching commissioned from its experts or those who emulated them.

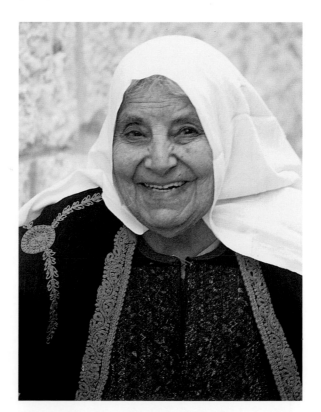

Maneh Hazboun, who introduced Bethlehem couching into Beit Dajan and other villages of the Jaffa area. Bethlehem, 1975.

EMBROIDERY SINCE 1948

During the hostilities surrounding the establishment of the state of Israel in 1948, an estimated three quarters of a million villagers fled or were driven from their homes in the Galilee hills or on the coastal plain, expecting to return when peace was restored. They never did, and most have since lived in refugee camps or towns in the Gaza Strip, the West Bank, Lebanon, Syria, Jordan or Egypt. The more than three hundred and fifty villages these families abandoned, and others, were subsequently demolished by the government of Israel. Many Palestinians remained, however, and now form a large minority within the Jewish state. A second wave of Palestinian refugees was created by the Six Day War of 1967, when Israel captured the Golan Heights from Syria, the West Bank from Jordan and the Gaza Strip from Egypt. These 'Occupied Territories' and their Arab inhabitants have since been under Israeli military control, although the newly created Palestinian National Authority was granted limited powers in the West Bank in 1994 and has had jurisdiction over the Gaza Strip since 2005.

The hardships and dislocations of the past six decades have profoundly affected every aspect of Palestinian life and culture. The art and language of embroidery has nevertheless persisted, partly under the stimulation of income-generating projects by Palestinian and other welfare associations which commission embroidered cushions and garments from village women, partly because women themselves want to continue their traditions, albeit in greatly changed forms. The political situation also caused embroidered dresses to acquire nationalistic significance and they are worn by dance troupes and on demonstrations by urban girls who wear jeans and T-shirts in everyday life.

The worsening economic situation of the Palestinians under Israeli occupation has made embroidery difficult to afford during the early twenty-first century, and many women of village origin now wear Western fashions or variations of unadorned 'Islamic' dress. Nonetheless, many living in the West Bank and Gaza strip, and in Jordan, are still making and wearing embroidered garments, although the fabrics used, and the embroidery motifs and colours, are very different from earlier fashions. Certain elements of dress and embroidery are also still being self-consciously employed to signify a woman's origins, not just by those still living in their natal homes, but also among refugees who left their villages decades ago, and even among their daughters who have lived all their lives in exile. Such is the human desire for identity and homeland.

OPPOSITE: Map of Palestine before 1948, showing main towns and largest villages.

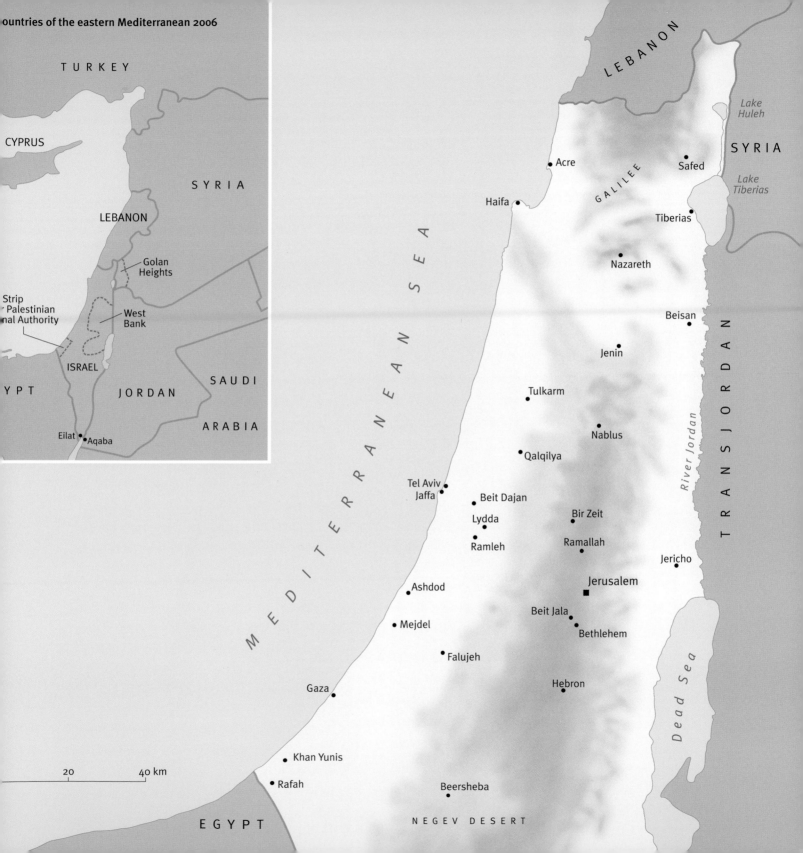

countries of the eastern Mediterranean 2006

TURKEY

CYPRUS

SYRIA

LEBANON

Golan
Heights

Strip
Palestinian
nal Authority

West
Bank

ISRAEL

YPT

JORDAN

SAUDI

ARABIA

Eilat
Aqaba

LEBANON

LAKE

SYRIA

Lake
Huleh

Acre

Safed

GALILEE

Lake
Tiberias

Haifa

Tiberias

Nazareth

Beisan

Jenin

TRANSJORDAN

Tulkarm

River Jordan

Nablus

Qalqilya

Tel Aviv

Jaffa

Beit Dajan

Bir Zeit

Lydda

Ramallah

Ramleh

Jericho

Jerusalem

Ashdod

Beit Jala

Mejdel

Bethlehem

Falujeh

Dead Sea

Gaza

Hebron

20 40 km

Khan Yunis

Rafah

Beersheba

EGYPT

NEGEV DESERT

M E D I T E R R A N E A N S E A

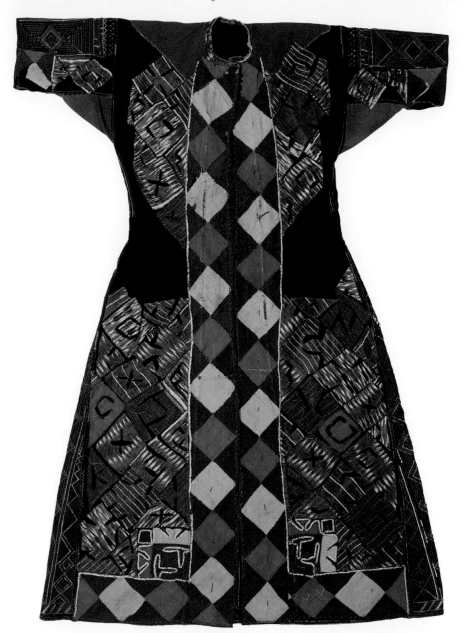

COAT (*JILLAYEH*)
Galilee, 19th century
The main fabric is indigo-blue cotton, with yoke and underarm inserts in rust-red cotton.

The coat is lavishly decorated with silk embroidery (see over), appliqué patches of green,
red and yellow taffeta (*heremzi*) and striped and ikat-dyed satins (*atlas*).
121 × 89 cm (47³/₄ × 35 in)

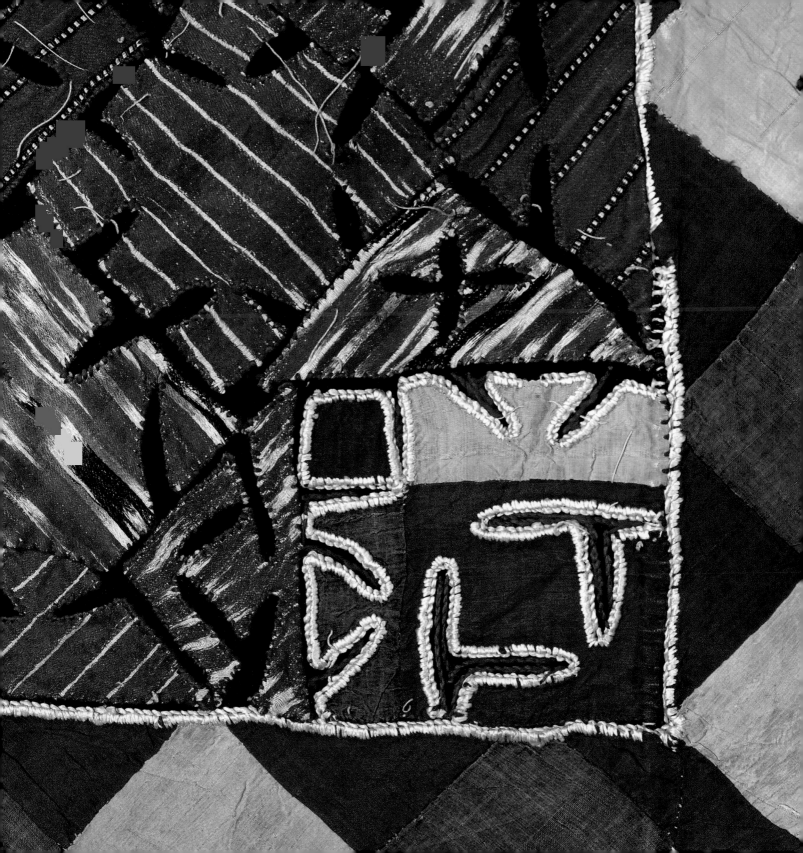

THE SILK THREAD ON THE BACK OF
THE COAT IS REMARKABLY DENSE,
AND WAS CLEARLY INTENDED TO
PROCLAIM WEALTH. THE REPEAT
PATTERN IS EXECUTED MAINLY IN
SATIN STITCH; OTHER STITCHES
INCLUDE A LINE OF DRAWN-
THREAD WORK (LEFT).

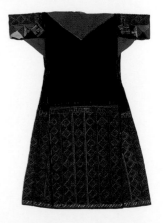

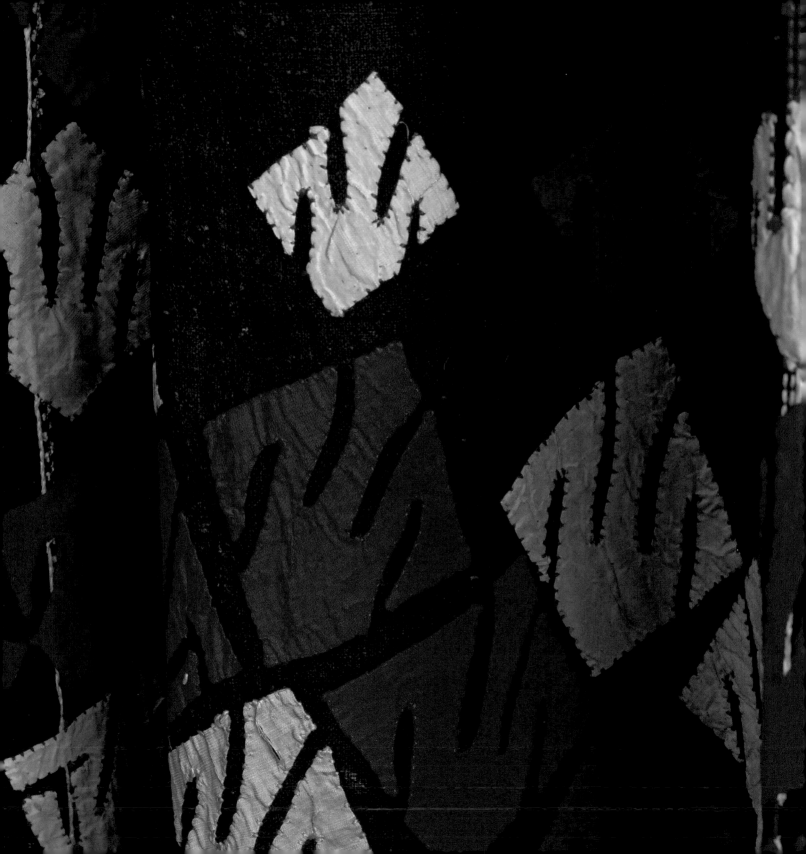

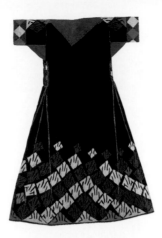

COAT (*JILLAYEH*)
Galilee, 19th century

The indigo-blue cotton is decorated with green, red and yellow taffeta (*heremzi*) appliqué patchwork.
141 × 84 cm (55^1/$_2$ × 72^1/$_2$ in)

THE STITCHES USED TO ATTACH THE INTRIGUINGLY SHAPED TAFFETA PATCHES ARE CLEARLY VISIBLE ON THE INSIDE SURFACE (RIGHT), SHOWING THAT THIS COAT WAS INTENDED TO BE REVERSIBLE.

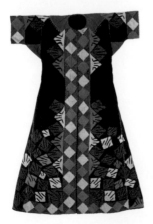

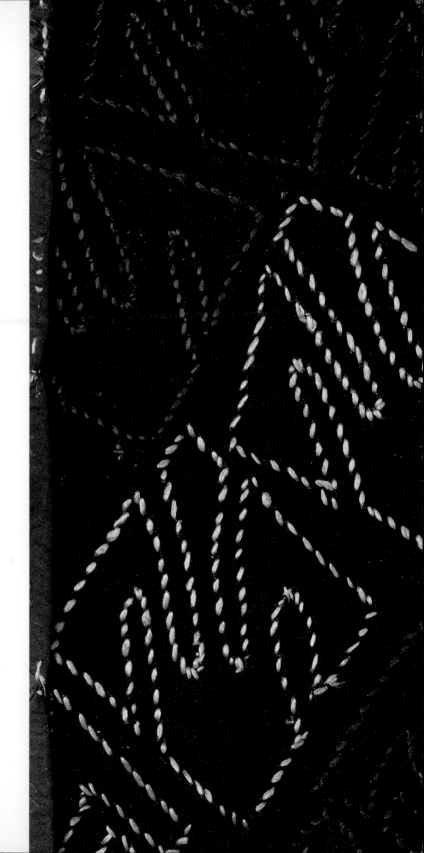

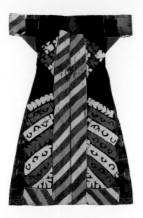

COAT (*JILLAYEH*)
Galilee, 19th century

The indigo-blue cotton is
decorated with green, red and yellow
taffeta (*heremzi*) appliqué patchwork and
silk-thread embroidery. In contrast to the
coats illustrated earlier, the patches are
oblong rather than square and are
internally slashed to create effect.
133 × 86 cm (52^1/$_2$ × 34 in)

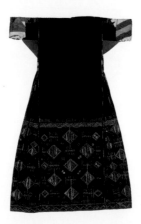

THE GEOMETRIC AND FLORAL MOTIFS ARE
SIMILAR TO THOSE ON THE COAT
ILLUSTRATED ON PAGES 24-7, BUT ARE
ARRANGED SO AS TO CREATE A DIFFERENT,
AND MORE OPEN, OVERALL PATTERN.

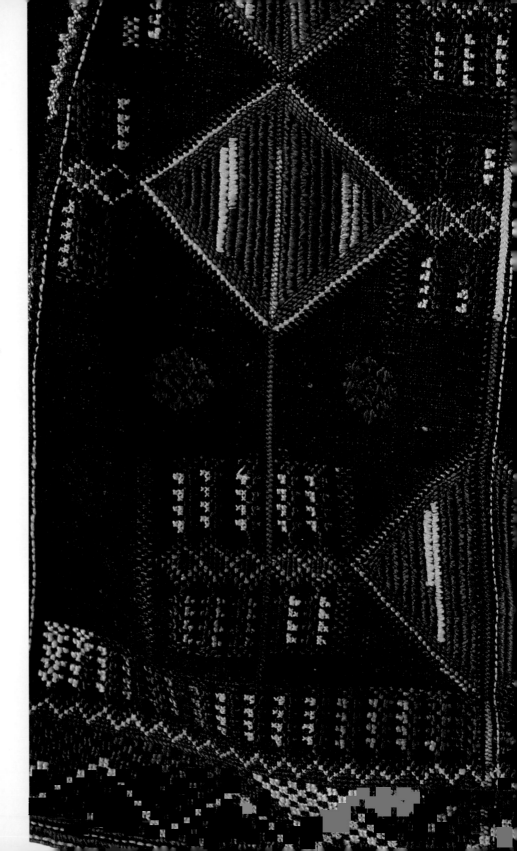

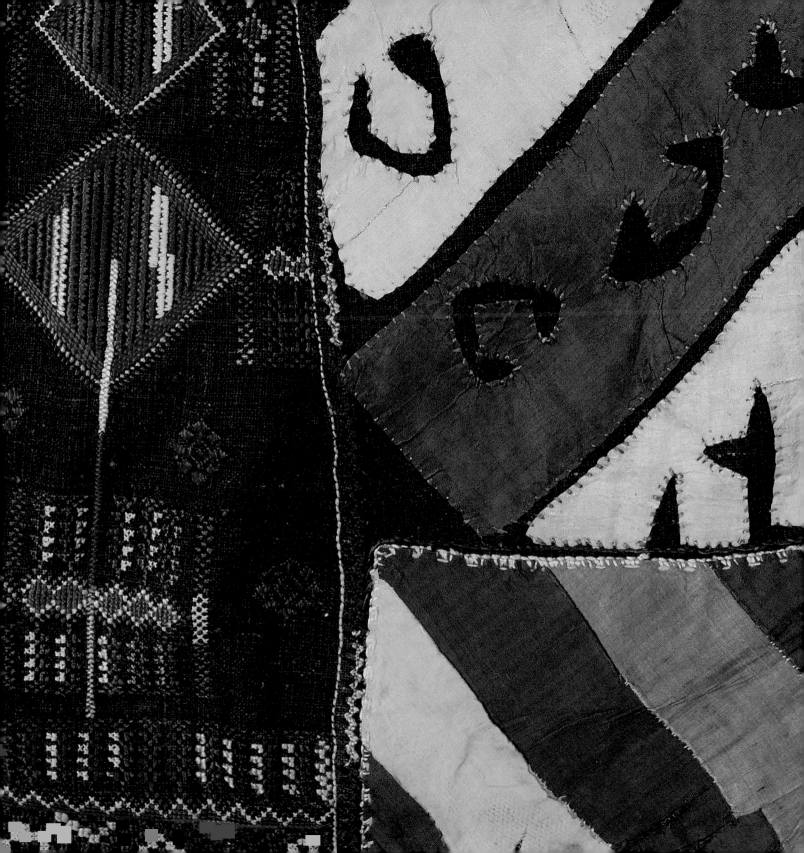

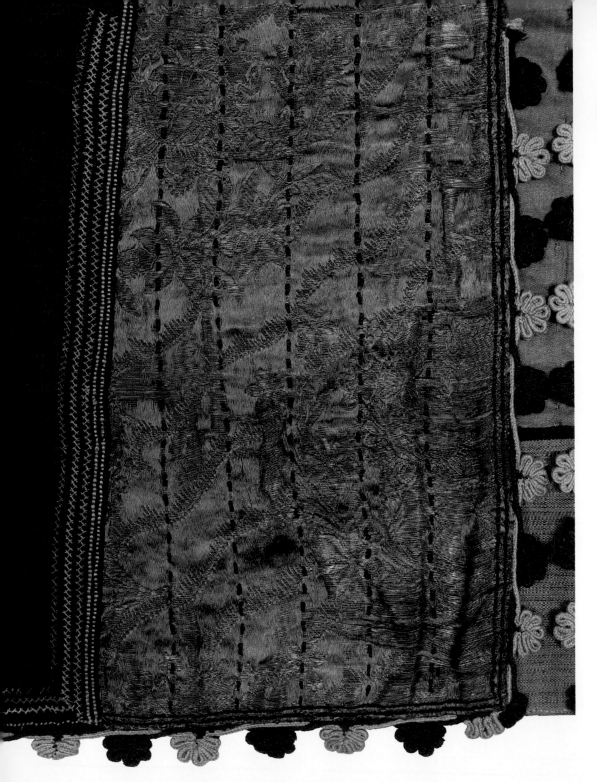

COAT (*DURA'AH*)
Druze, Galilee, late 19th or early
20th century

Most of this coat, apart
from the brown cotton sleeves,
is made from luxury fabrics
imported from Syria or Europe:
red satin and panels of blue and
silver silk brocade, which are
attached with large red running
stitches. The cord edging shows
Ottoman influence.
124 × 91 cm (49 × 36 in)

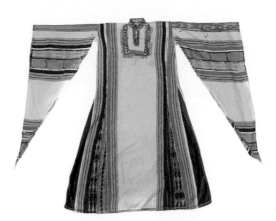

DRESS (*THOB*)
Anabta, near Nablus, *c.* 1930s

This dress is made from a locally
woven fabric called 'heaven-and-hell'
(*jinneh-u-nar*). It is of white cotton,
with green and red silk stripes at
the selvedge. The sides and sleeves
of the dress have inserts and
patches of striped and ikat-
patterned Syrian satin (*atlas*).
138 × 150 cm (54¹/₂ × 59 in)

THE SLEEVES ARE ATTACHED INSIDE
OUT AND WERE FOLDED BACK TO SHOW
THEIR DECORATIVE PANELS WHEN THE
DRESS WAS WORN.

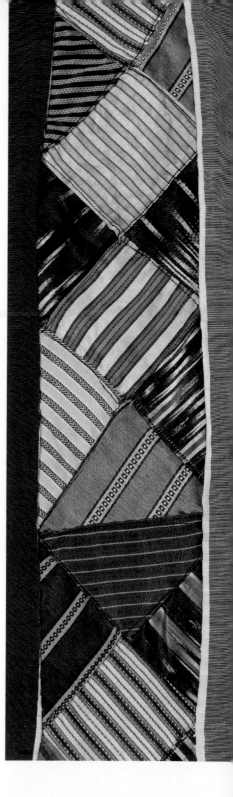

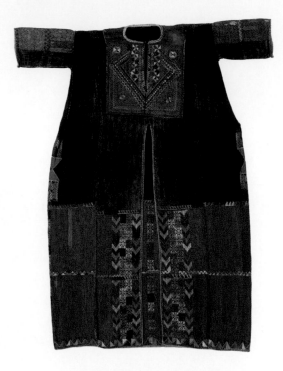

COAT-DRESS (*JILLAYEH*)
Ramallah, 19th century

The indigo linen is decorated with floss-silk embroidery,
mainly in orangey-red with touches of other colours on the skirt and chest
square. The lower part of the skirt is so densely embroidered that the
background fabric is almost entirely concealed. The predominant pattern is
the zigzag 'tall palms' motif which was, as here, usually executed in double-
sided cross stitch. This was the main symbolic marker of
Ramallah and its surrounding villages.
127 × 105 cm (50 × 41½ in)

THE SOLID EMBROIDERY COVERING MOST OF THE SKIRT CONTRASTS
WITH THE DELICATE PATTERNS IN YELLOW, GREEN, MAUVE, WHITE AND
PINK WHICH EDGE THE SKIRT OPENING.

OVERLEAF: DETAIL FROM THE CHEST PANEL OF THIS COAT-DRESS.

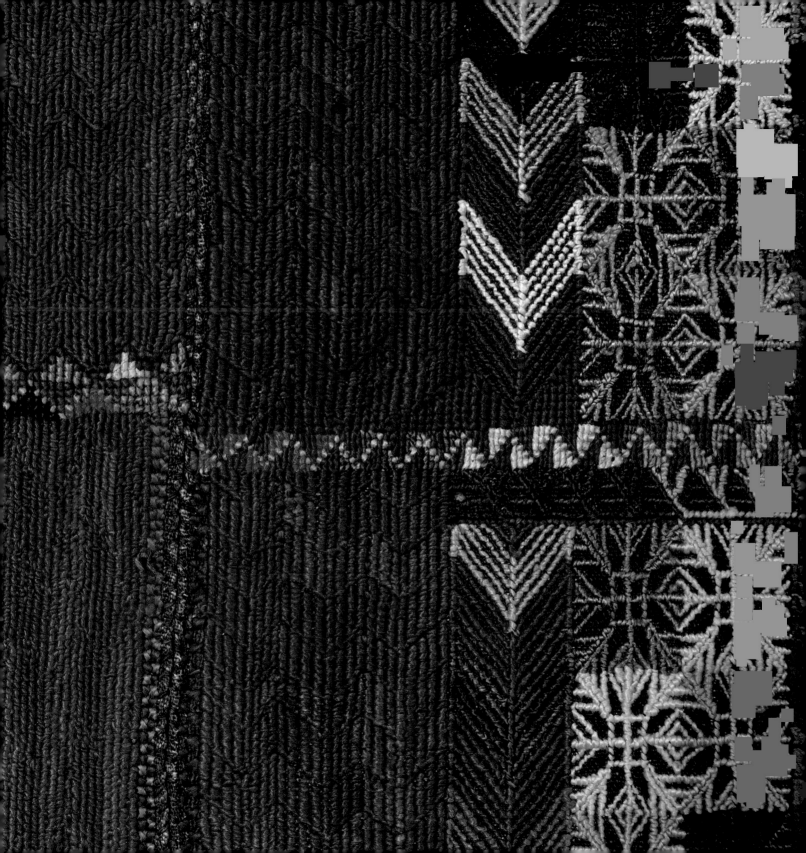

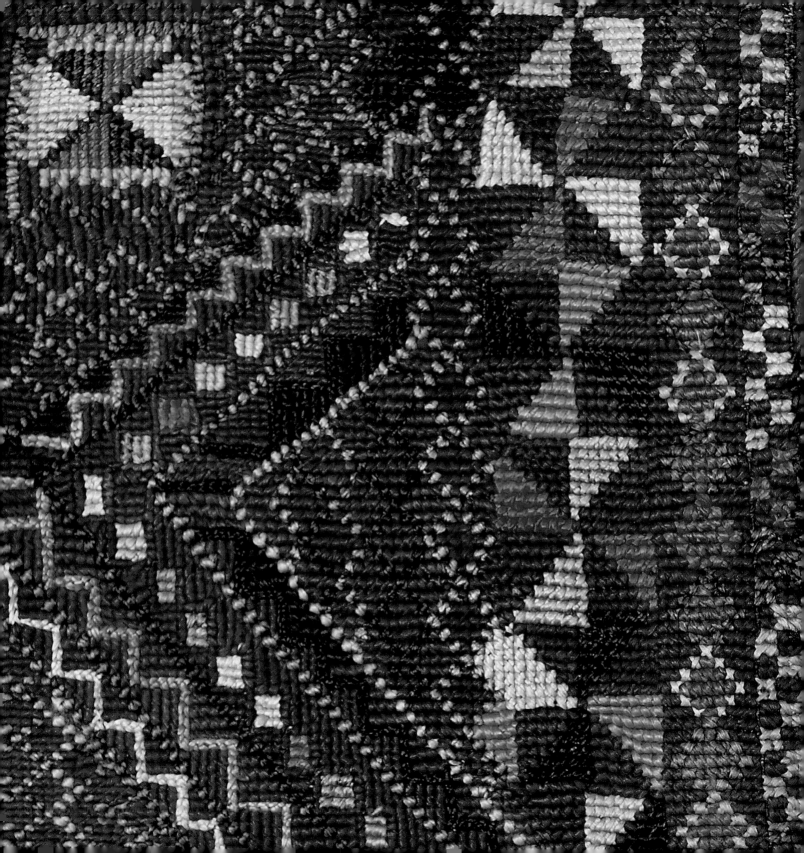

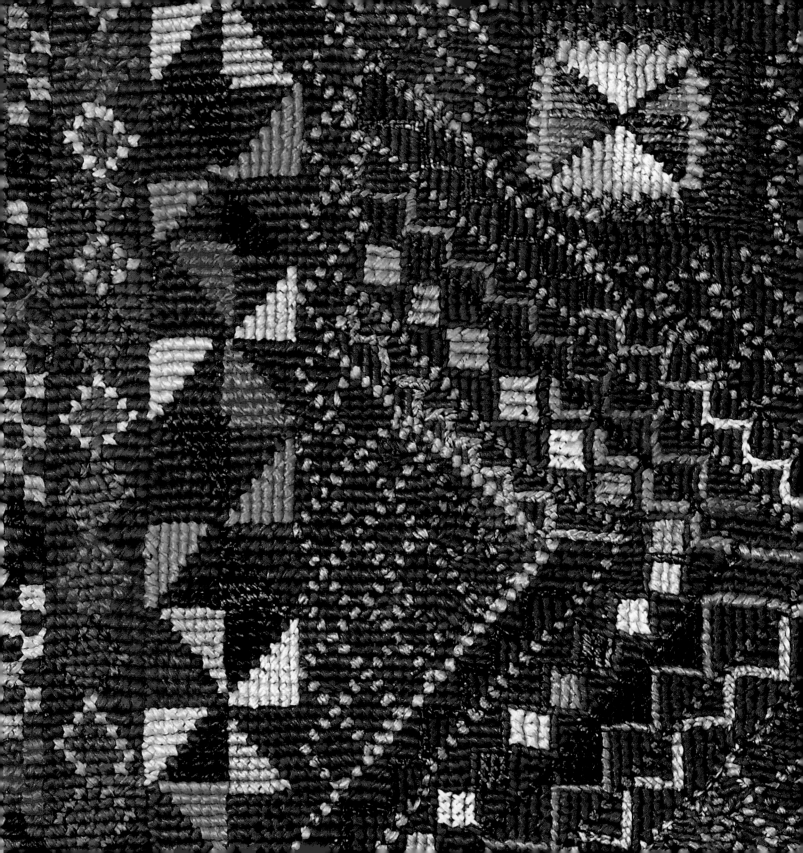

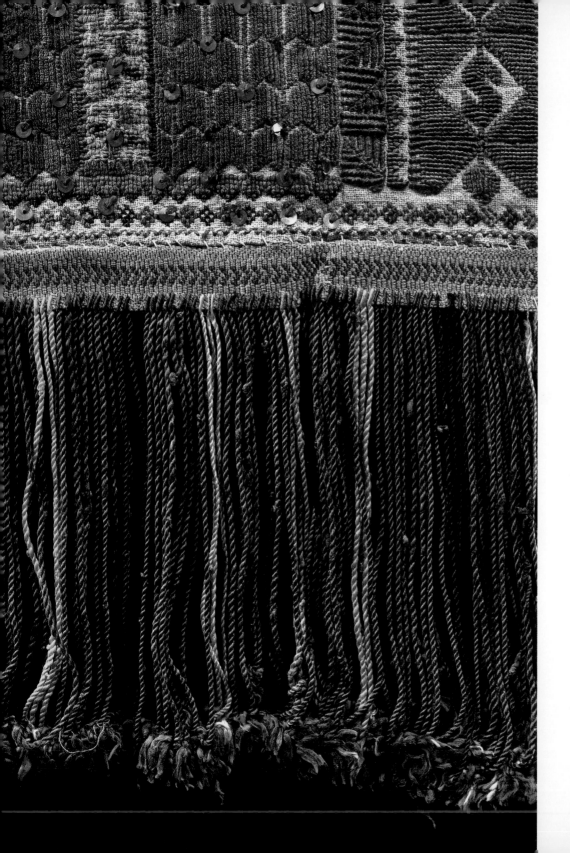

VEIL (*KHIRQAH*)
Ramallah, early 20th century

The fabric is natural linen
and the embroidery is in the same
orangey-red floss silk as the dress
on the previous pages. Typical of
the Ramallah district are the 'tall
palm' patterns at each end of the
veil, and the S-shaped motifs
along the edges. The little birds
added to the predominantly
geometrical design show
European influence.
198 × 88 cm (78 × 34$^{1}/_{2}$ in)

THE EMBROIDERY IS ENLIVENED WITH
SEQUINS AND THE VEIL IS FINISHED
WITH A LUXURIOUS TASSELLED FRINGE.

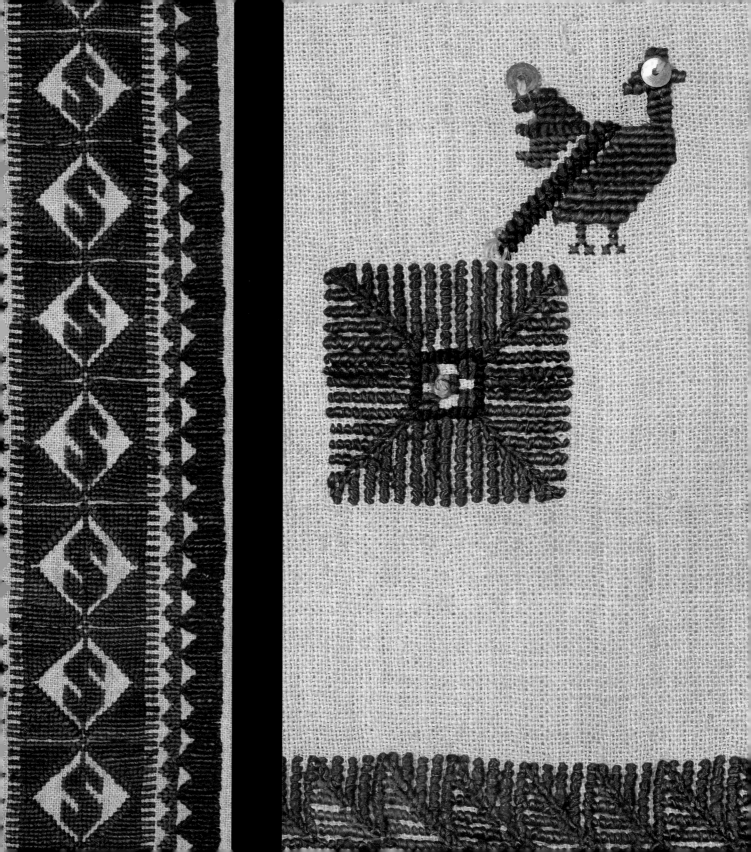

DRESS (*THOB*)
Ramallah area, *c*.1900

This dress is made of natural linen, with embroidery
mainly in red with touches of black, green and pink. Older geometric patterns are
combined with dainty curvilinear motifs introduced by
European missionaries and educationists.
136 × 146 cm (53^1/$_2$ × 57^1/$_2$ in)

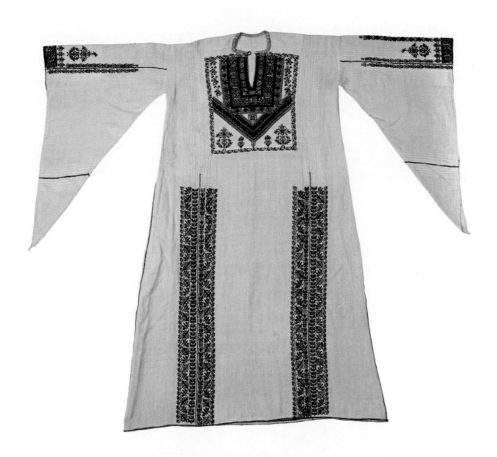

FLORAL AND BIRD MOTIFS (SEE OVERLEAF) OF EUROPEAN
ORIGIN ARE INCORPORATED INTO THE TRADITIONAL
EMBROIDERY STRUCTURE OF THE GARMENT.

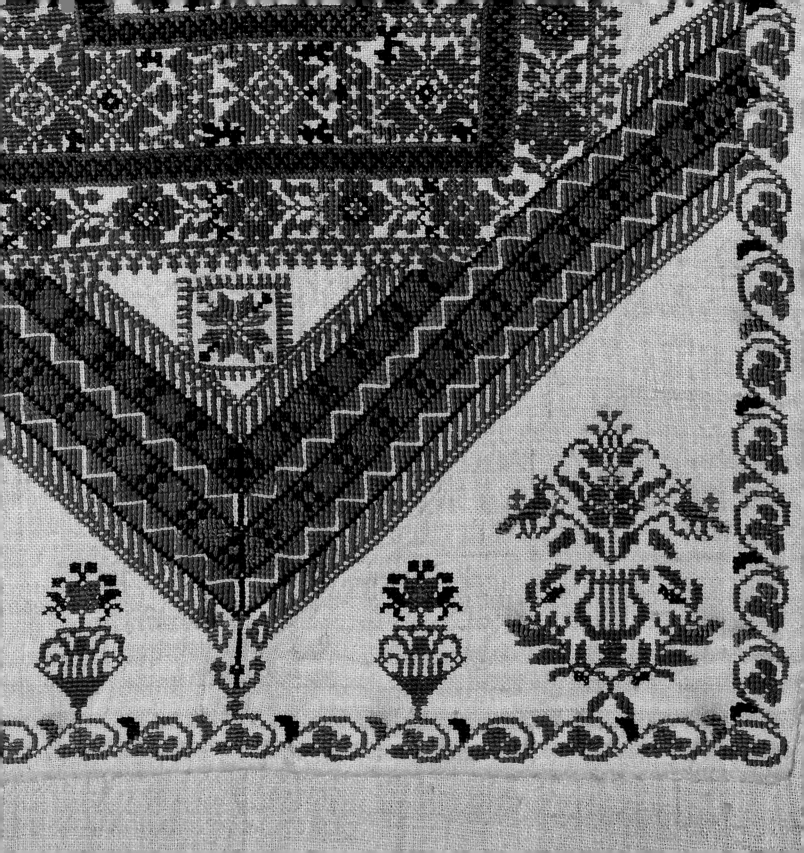

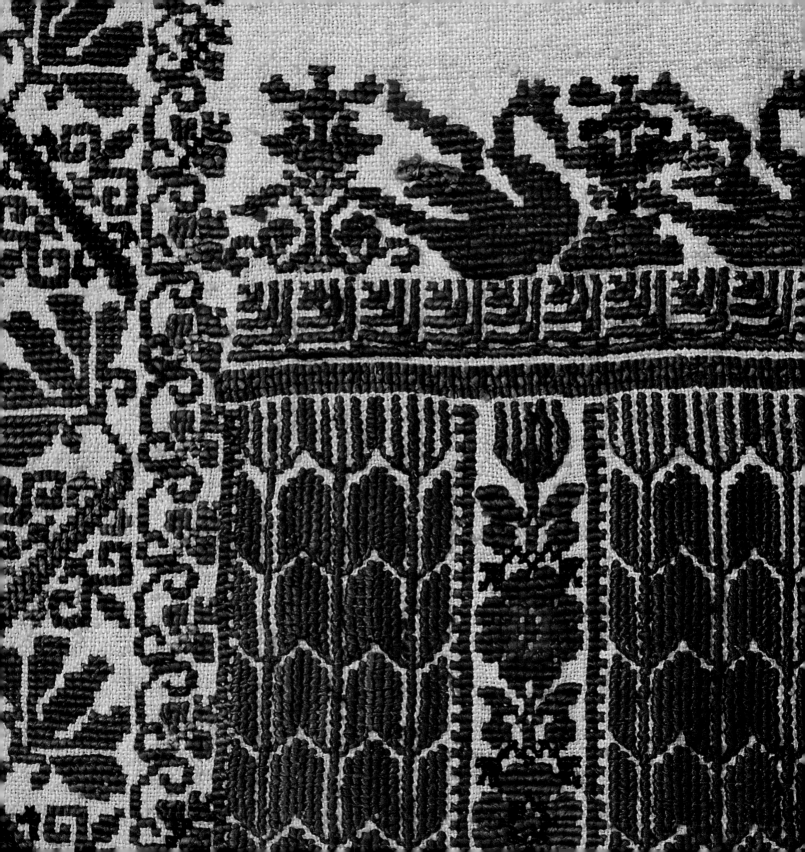

DRESS (*THOB*)
Beit 'Ummar, north of Hebron, 1930s–1940s

This dress of dark blackish-blue linen has a yoke of striped satin and panels of
'royal' (*malak*) fabric inserted in the sleeves. The embroidery is mainly in purple
cross stitch with touches of other colours. There is also some Bethlehem-style
couching on the chest panel and collar (see overleaf).
152 × 138 cm (60 × 54½ in)

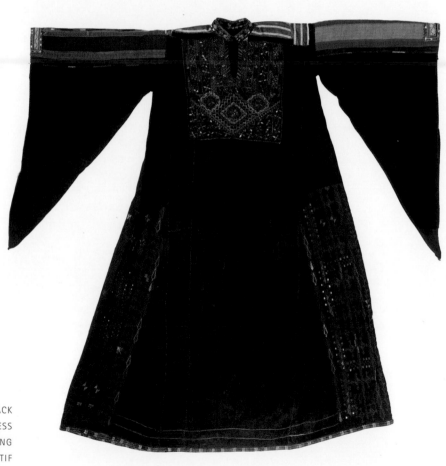

LEFT: DETAIL FROM THE BACK
SKIRT PANEL OF THE DRESS
ON PAGES 40–41, SHOWING
THE 'TALL PALM' MOTIF
DISTINCTIVE OF RAMALLAH
AND FLORAL AND SWAN
MOTIFS OF EUROPEAN ORIGIN.

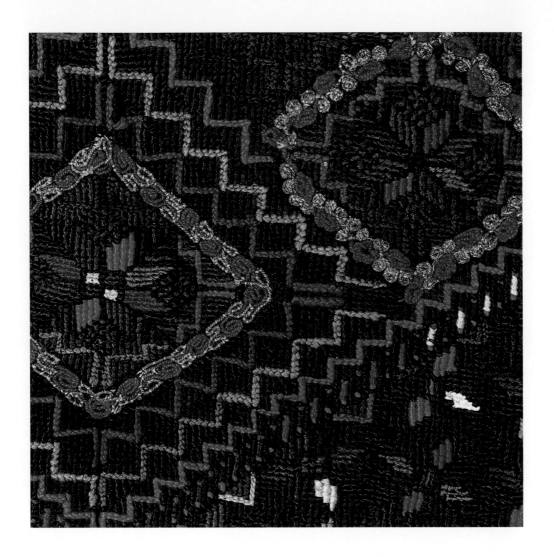

BETHLEHEM INFLUENCE IS EVIDENT IN THE BORDERS
AND ROSETTES IN METALLIC CORD COUCHING AND THE
HERRINGBONE FRAMES.

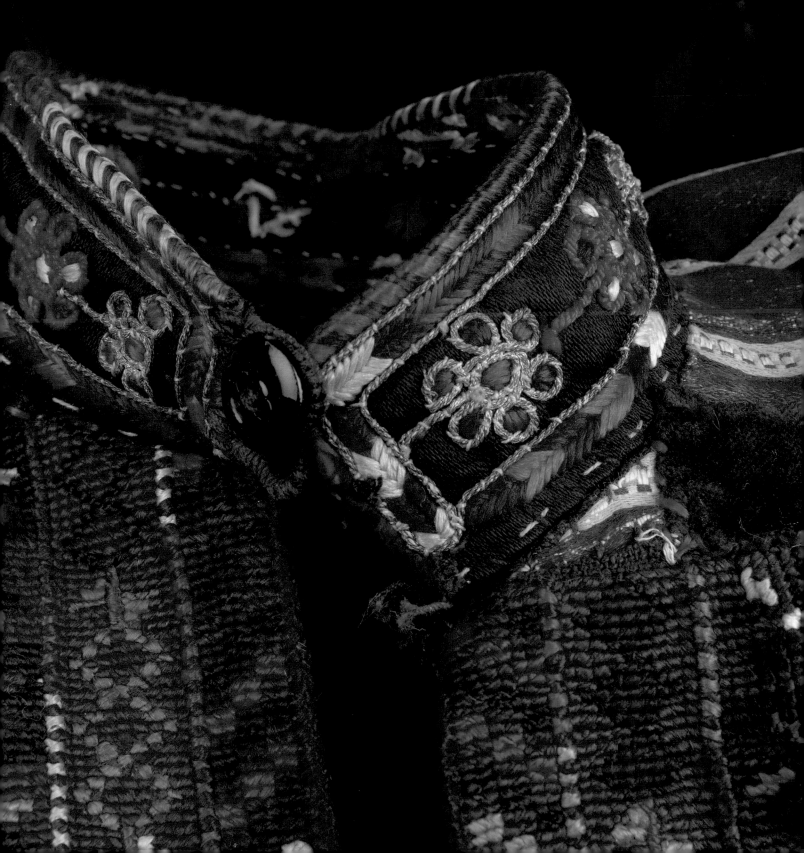

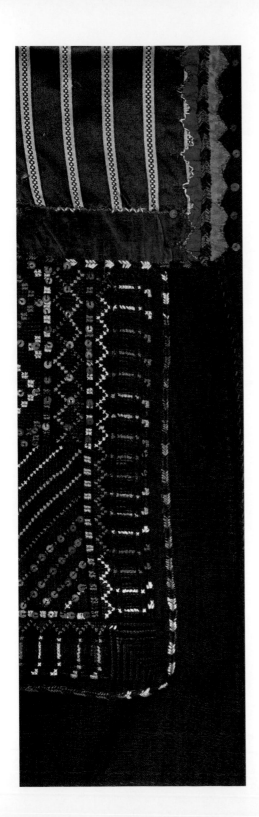

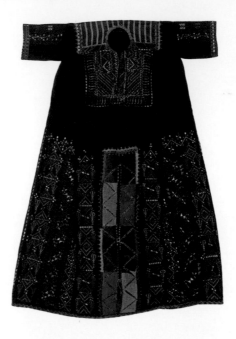

COAT-DRESS (*JILLAYEH*)
Beit Dajan, near Jaffa, *c.* 1920

This was the best dress in the bride's part of the trousseau until after the First World War. The opening in the front of the skirt is patched with maroon, orange and green taffeta (*heremzi*) and decorated with sequins. The yoke is of satin (*atlas*), edged with zigzag appliqué (*tishrimeh*), with a patch of luxury velvet.
135 × 94 cm (53 × 37 in)

THE BEADED AND TASSELLED TIES CLOSING THE SKIRT AND NECK OPENINGS WERE SUPPOSED TO ATTRACT MALE ATTENTION. BLUE BEADS WERE ALSO BELIEVED TO AVERT THE EVIL EYE.

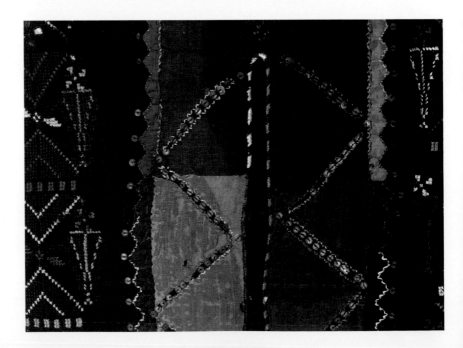

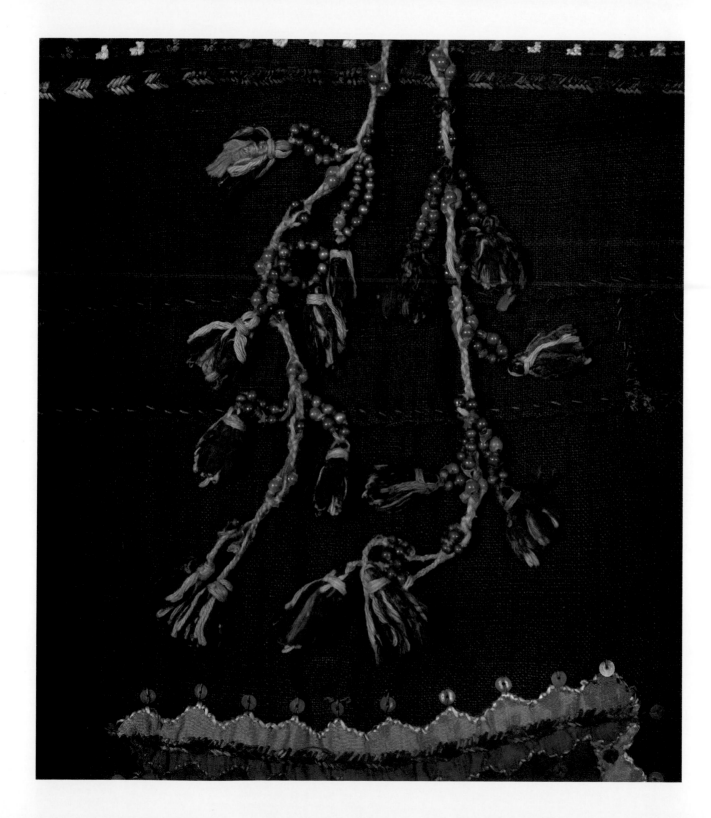

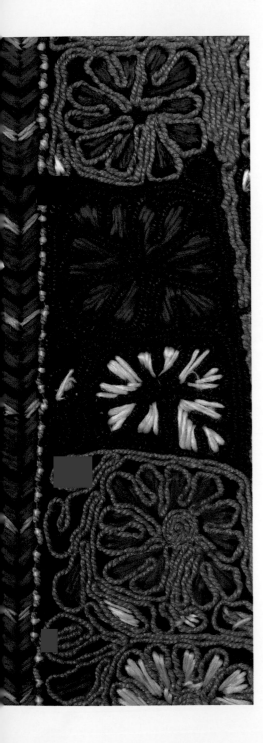

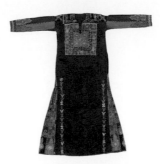

DRESS (*THOB*)
Deir Terif, near Jaffa, 1930s–1940s

The ribbed silk fabric (*kermesot*) is decorated with couching in silk cord and metallic threads filled with satin stitch. The techniques and patterns originated in Bethlehem, but have a unique character all of their own.
139 × 138 cm (54³/₄ × 54¹/₂ in)

THE SIMPLE FLORAL MOTIFS ON THE BACK OF THE SKIRT (RIGHT) ARE PARTICULARLY STRIKING AGAINST THE PURPLE BACKGROUND.

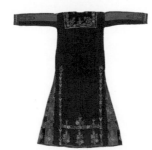

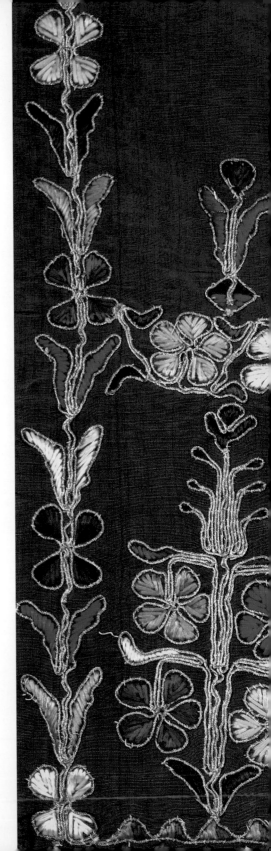

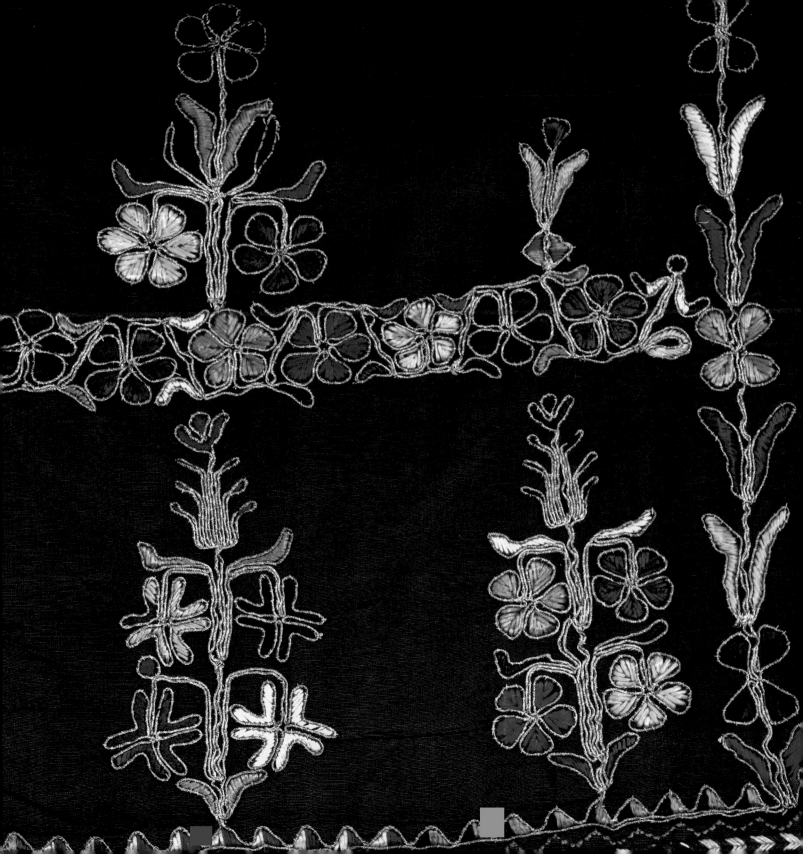

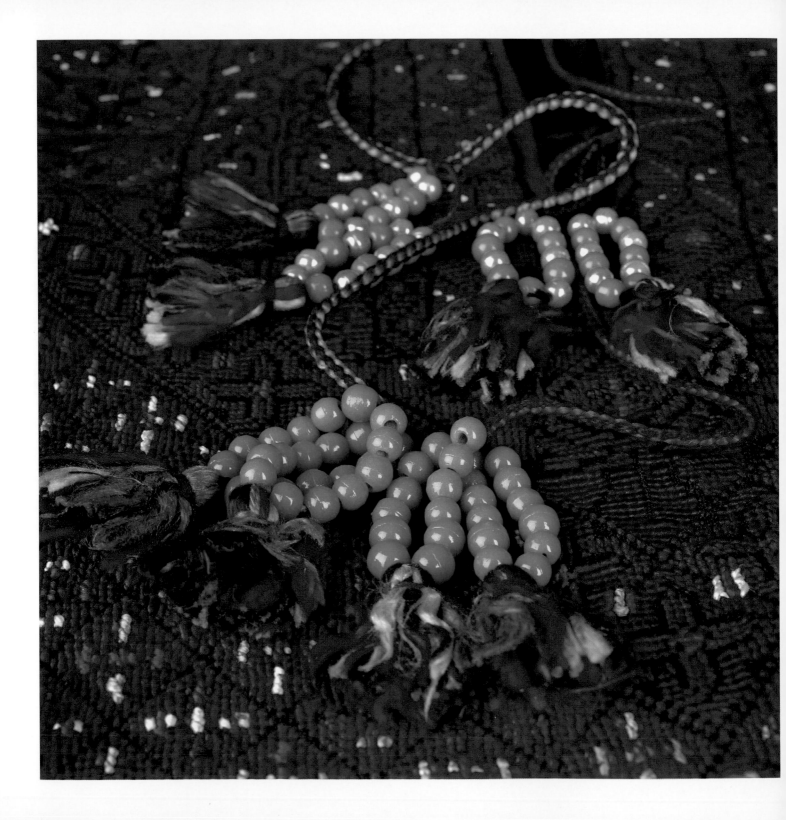

DRESS (*THOB*)
al-Na'ani, south of Ramleh, 1930s–1940s

The fabric is blue-black linen. It is decorated
with mainly cross-stitch embroidery, simple couching in
white cord on the yoke and satin-stitch seam stitching. This
village was famous for its fine cross stitch, which was
emulated by neighbouring villages. The embroidery is
particularly dense on the chest square (left). The bird (below)
and other motifs (right) show European influence.
140 × 150 cm (55 × 59 in)

THE NECK TIES, WITH THEIR IMITATION
PEARLS, BLUE BEADS AND SILK
TASSELS, PROVIDE AN EYE-CATCHING
CONTRAST TO THE GENERALLY
RESTRAINED DECORATION OF THE
REST OF THIS DRESS.

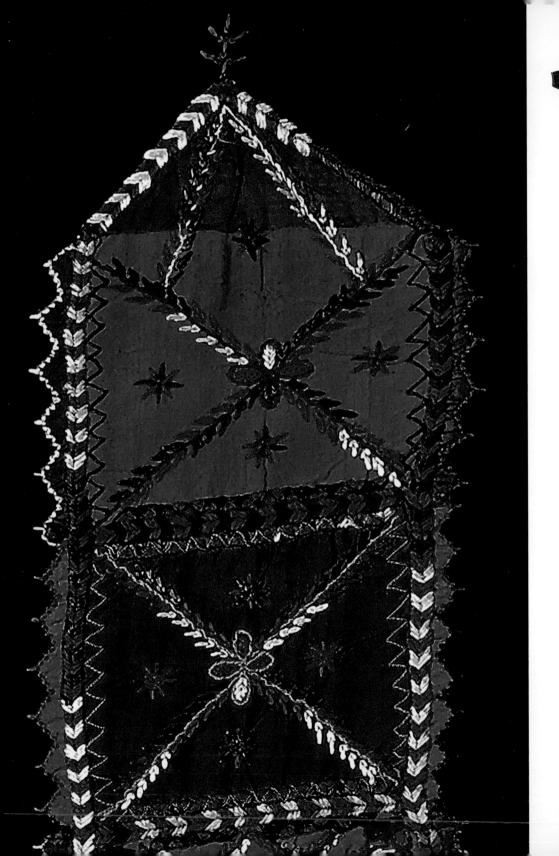

DRESS (*THOB*)

Masmiyyeh or al-Na'ani area, south of Ramleh, *c.* 1920

This dress is made of blue-black linen, with cross-stitch embroidery, a yoke of striped satin (*atlas*) and an appliqué panel on the front of the skirt of red and orange taffeta (*heremzi*).
135 × 135 cm (53 × 53 in)

THE SKIRT PANEL IS EMBROIDERED WITH IMITATION COUCHING, HERRINGBONE AND SATIN STITCHES, AND HAS A ZIGZAG EDGING (*TISHRIMEH*) – ALL INSPIRED BY BETHLEHEM EMBROIDERY.

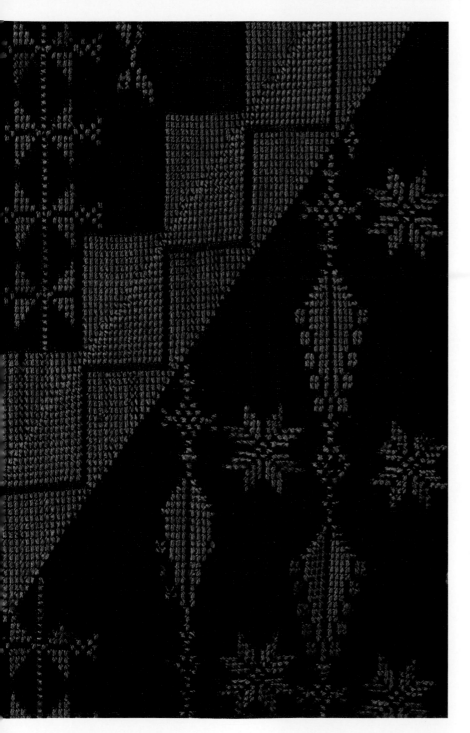

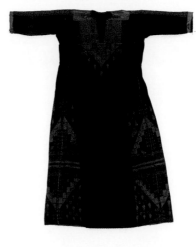

DRESS (*THOB*)
South-west coastal plain,
late 19th or early 20th century

The fabric of indigo-blue
cotton has cross-stitch embroidery in
orangey-red silk. The festive dresses of
the villages near Gaza were notable
for the huge chevrons and 'cypress
tree' motifs (see overleaf) with
which they were decorated.
144 × 116 cm (56³/₄ × 45³/₄ in)

THE PLAIN BLUE COTTON FABRIC
PROVIDES A PERFECT BACKGROUND
FOR THE LUSTROUS SHEEN OF THE
MONOCHROME EMBROIDERY.

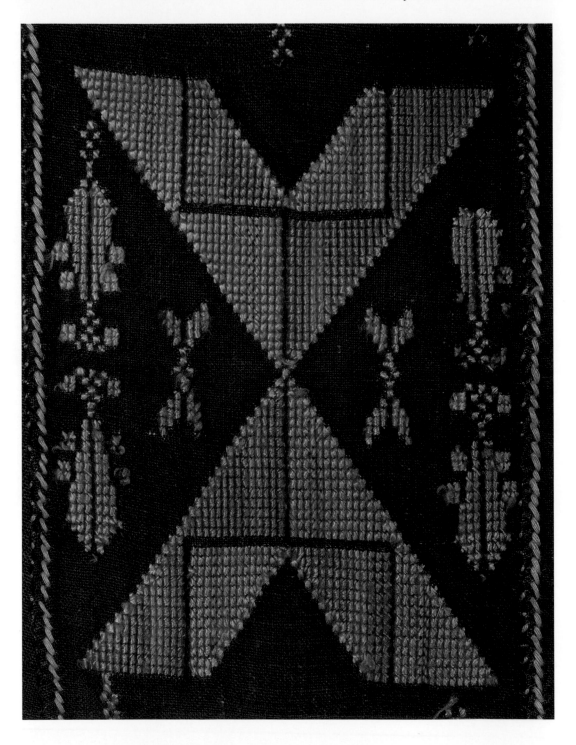

DETAILS FROM THE
DRESS ILLUSTRATED ON
THE PREVIOUS PAGE.

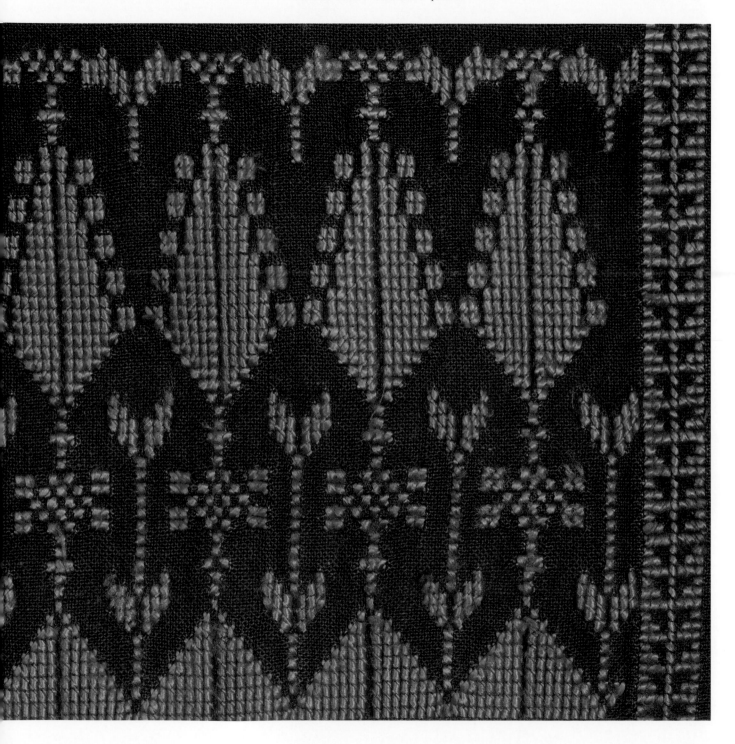

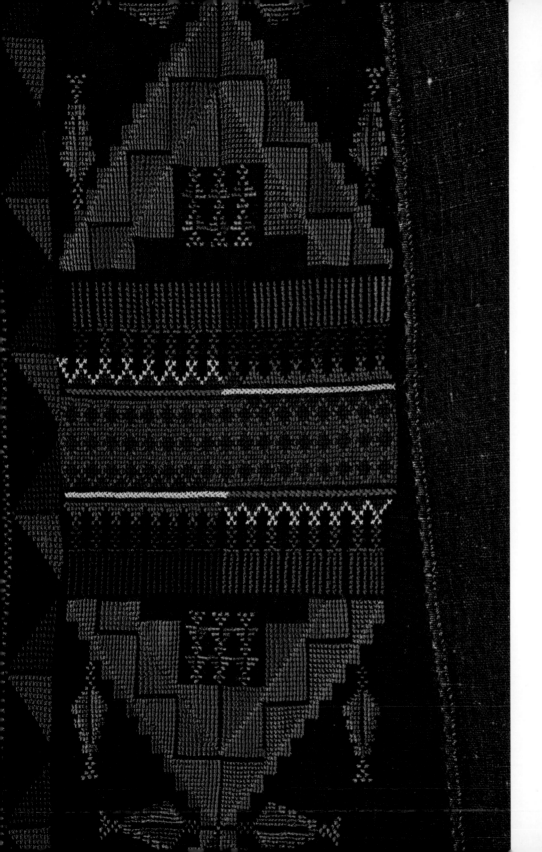

DRESS (*THOB*)
South-west coastal plain, *c*.1920s

This indigo-blue cotton dress has cross-stitch embroidery in shades of red, orange and mauve with touches of other colours. The sides have been salvaged from an older garment. The chest square and sleeves probably date from the 1930s or 1940s.
140 × 133 cm (55 × 52½ in)

THE HARMONY OF WARM COLOURS MAKES THE SIMPLE GEOMETRIC PATTERNS MORE INTERESTING AND BEAUTIFUL.

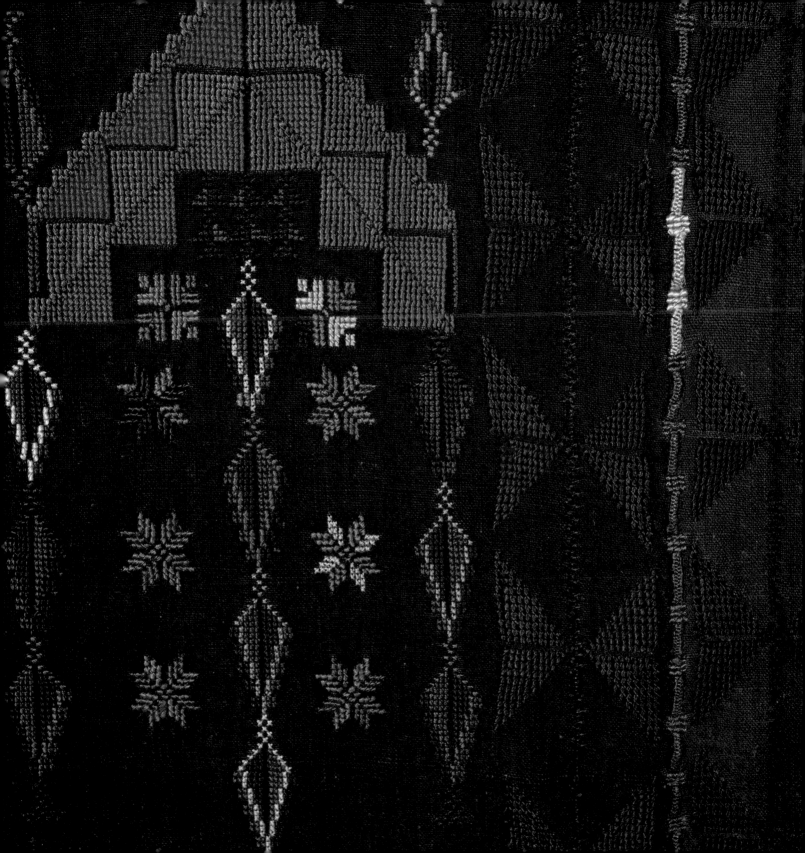

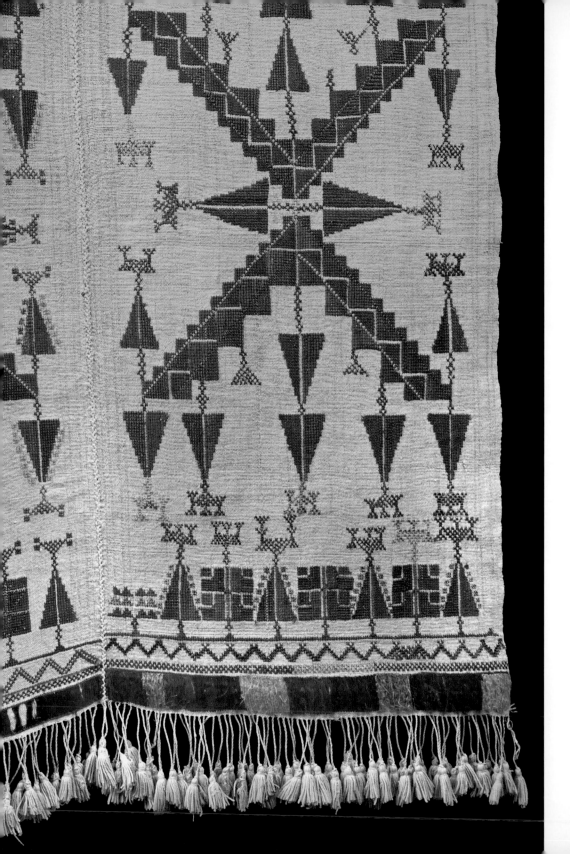

VEIL (*GHUDFEH*)
Falujeh, southern coastal plain,
1920s or earlier

The natural linen fabric is decorated
with cross-stitch embroidery mainly
in red, with some green and yellow.
178 × 110 cm (70 × 43¹/₄ in)

THE BOLD CHEVRONS AND CYPRESS
TREE PATTERNS ARE OFFSET BY THE
DELICATE LINEN FRINGE BORDERED BY
LONG FLOATING SATIN STITCHES.

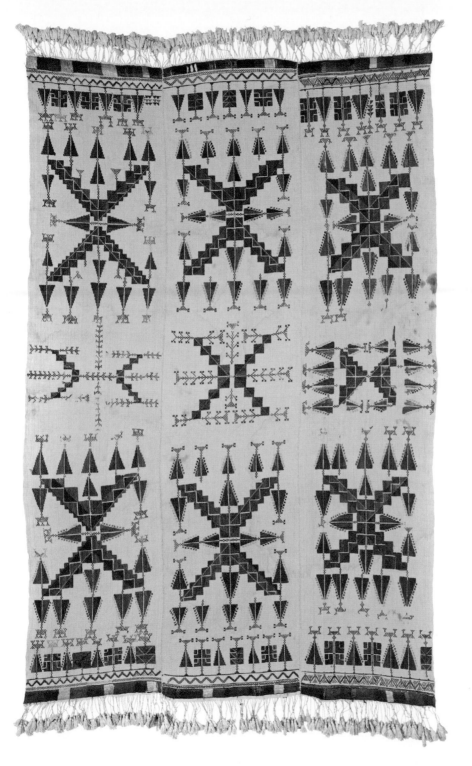

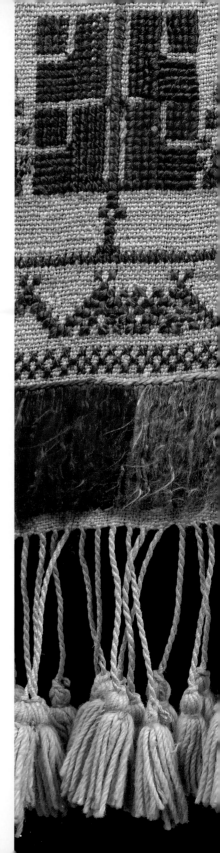

59

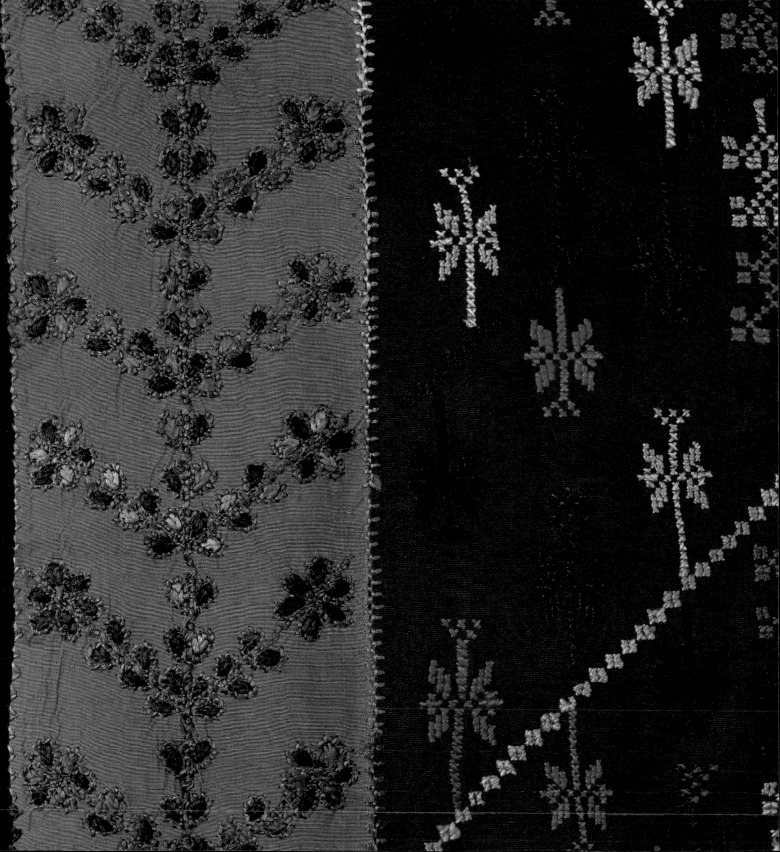

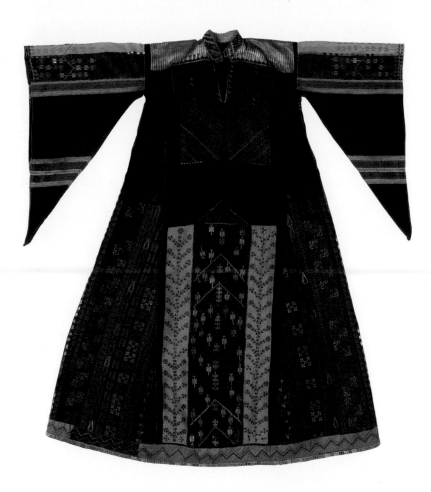

DRESS (*JILLAYEH*)
Southern plain, *c.* 1920s

This dress is made from an indigo-blue cotton fabric
and has sleeves of cotton with silk stripes. The yoke is of satin (*atlas*) and the sleeve
inserts, front skirt panel and hem border are of red and orange taffeta (*heremzi*). The
embroidery is in mainly red cross stitch, with multicoloured cross-stitch, running
and satin stitches on the skirt appliqué panels.
137 × 126 cm (54 × 49³/₄ in)

THE GREY AND BLACK EMBROIDERY (FAR LEFT) IS PARTICULARLY
EFFECTIVE AGAINST THE ORANGE TAFFETA BACKGROUND.

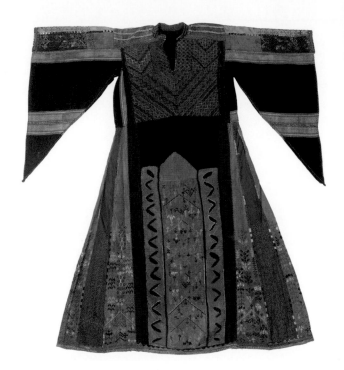

DRESS (*JILLAYEH*)
Hebron Hills, *c.*1920s

The main fabric is blue-black
cotton with red silk stripes at the selvedge.
The chest panel and back skirt panel
(salvaged from an older dress) are heavily
embroidered in mainly red cross stitch. The
yoke is made from satin (*atlas*). Lightly
embroidered panels of red and green taffeta
(*heremzi*) are inset in the sleeves and the skirt
sides. The skirt front is decorated with
appliqué panels of red and green taffeta
embroidered in cross stitch,
some slashed (see overleaf).
140 × 120 cm (55 × 47¹/4 in)

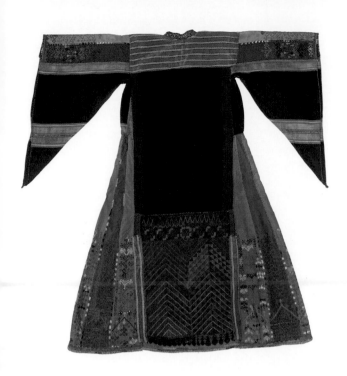

THE CROSS-STITCH EMBROIDERY
ON THE CHEST AND BACK OF
THE SKIRT FORMS A SOLID
BLOCK, DIVIDED BY DIAGONAL
LINES IN MULTICOLOURED
SILKS. THE USE OF DIFFERENT
SHADES OF RED AND PURPLE
FOR EACH SMALL TRIANGLE
CREATES A VARIEGATED EFFECT.

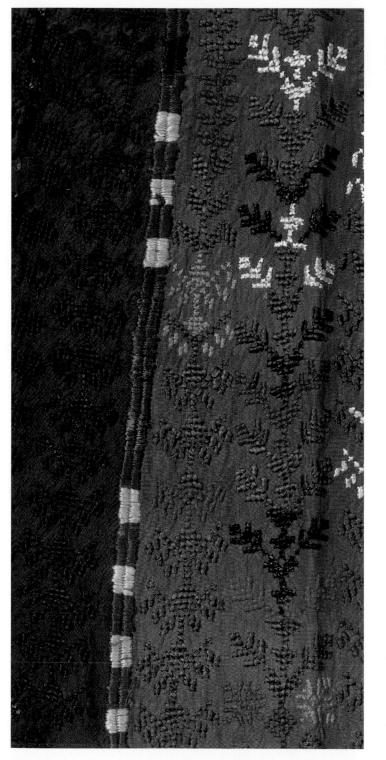
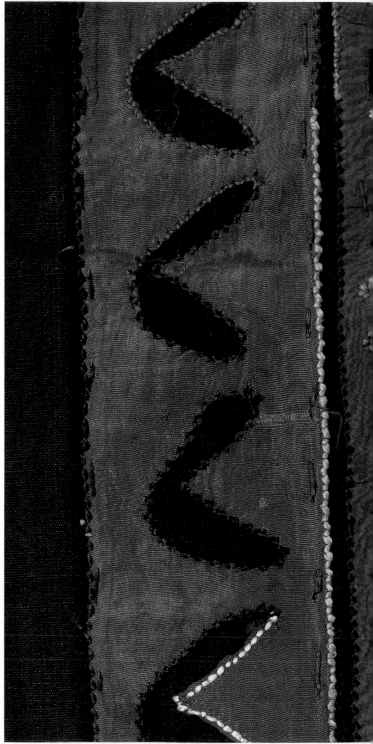

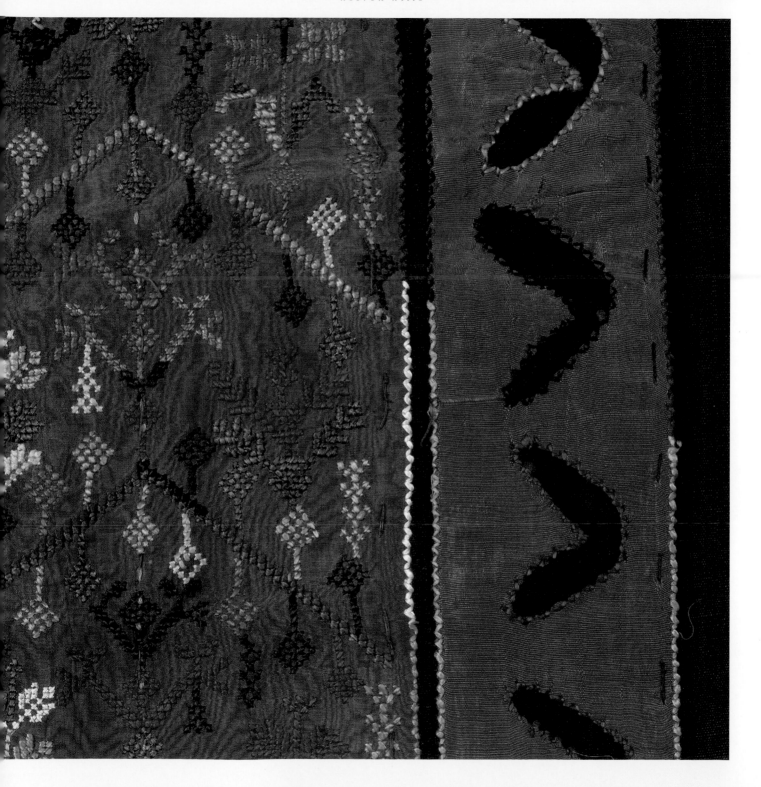

VEIL (*GHUDFEH*)
Hebron Hills, 1920s–1940s

The natural linen is embroidered in double-sided stitches. This type of embroidery was commissioned from professional embroiderers in Bethlehem and might have been influenced by visitors from mainland or island Greece.

288 × 124 cm (113$^{1}/_{2}$ × 49 in)

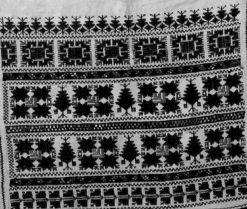
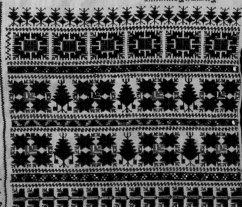

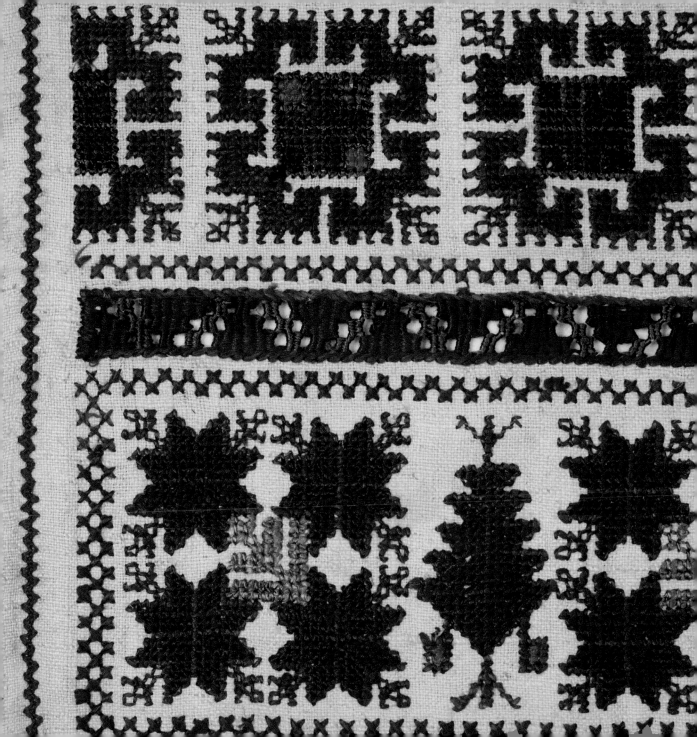

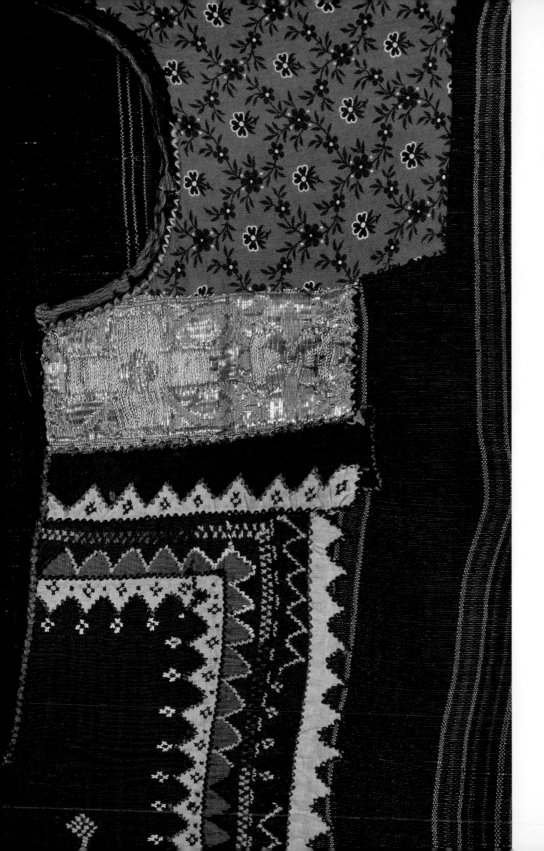

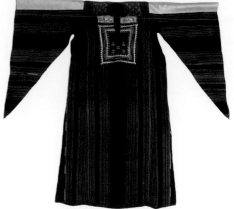

DRESS (*THOB*)
Bethlehem area, probably
late 19th century

The 'royal' (*malak*) fabric of striped silk
and linen was woven locally. The yoke is of
European cotton. There are yellow and red
taffeta (*heremzi*) inserts in the sleeves and
skirt sides. The chest panel is of red, green
and yellow taffeta appliqué with zigzag
(*tishrimeh*) edges, surmounted
by strips of metallic brocade.
168 × 83 cm (66 × 32½ in)

THIS DRESS COMBINES SEVERAL LUXURY
FABRICS OF VARIOUS ORIGINS. ITS MOST
STRIKING FEATURE IS THE CHEST PANEL,
WITH ITS CONTRASTING COLOURS AND
ZIGZAG EDGES.

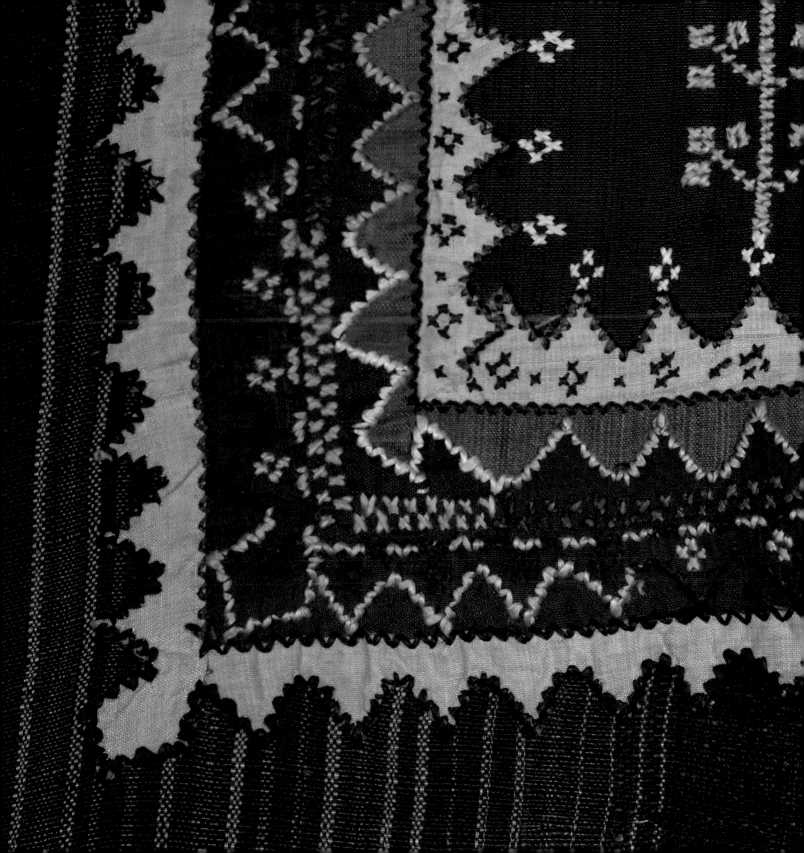

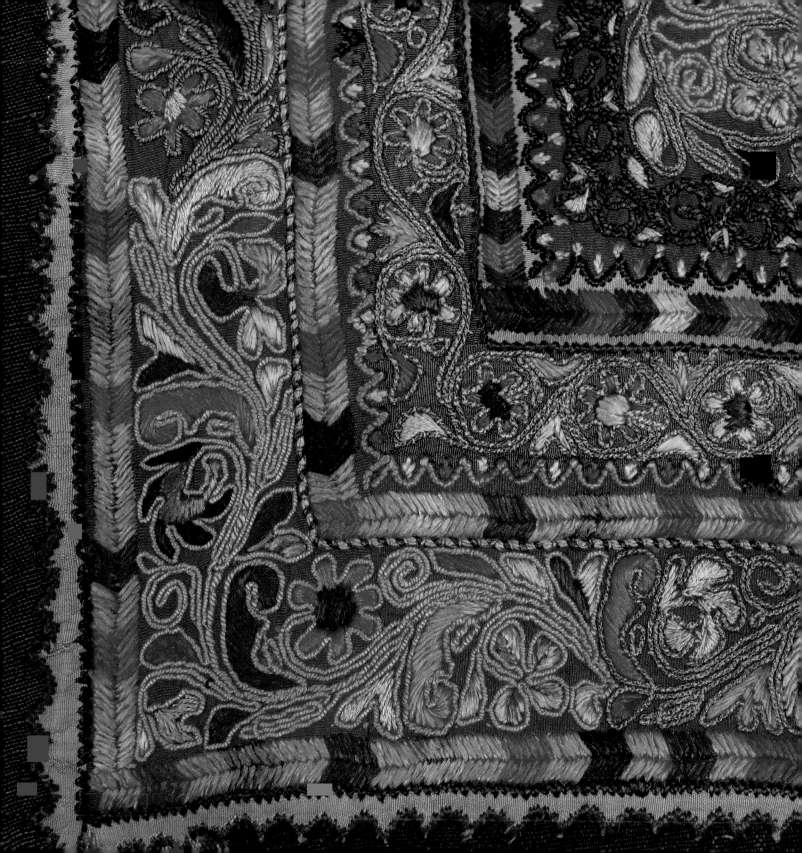

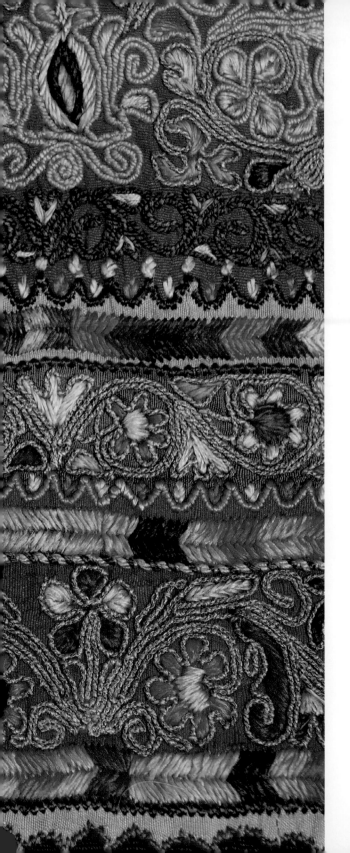

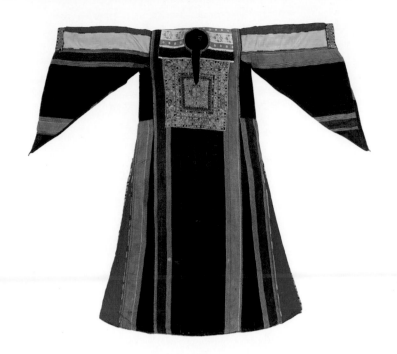

DRESS (*THOB IKHDARI*)
Bethlehem area, late 19th century

The main fabric is linen with
silk selvedge stripes. There are red and yellow
taffeta inserts in the sleeves and skirt. The
chest panel is couched with gilt cord and
yellow and green silk cord, and filled with
multicoloured satin and herringbone stitches.
The green and red taffeta background panel
can be glimpsed between the motifs, and the
panel has a yellow taffeta zigzag edging.
151 × 140 cm (39$^{1}/_{2}$ × 55 in)

THE FLOWING CURVILINEAR PATTERNS WITHIN
RECTANGULAR FRAMES, WARM HARMONIOUS
COLOURS AND LUSTROUS SILKS MAKE THIS
ONE OF THE MOST BEAUTIFUL EXAMPLES OF
BETHLEHEM EMBROIDERY.

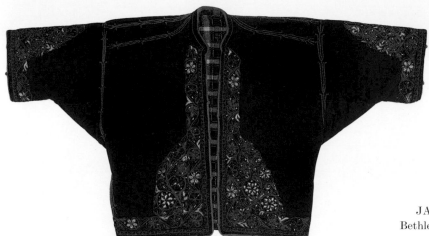

JACKET (*TAQSIREH*)
Bethlehem area, late 19th century

The green broadcloth is embroidered with
orange-cord couching and satin-stitch
filling. These jackets were worn over
women's best dresses in the hill villages
around Bethlehem and Jerusalem.
53 × 98 cm (24³/₄ × 38¹/₂ in)

[OPPOSITE] THE ROSETTES,
LEAVES AND TENDRILS,
TYPICAL OF BETHLEHEM
EMBROIDERY, ARE HERE
ARRANGED TO MAKE A
LARGE, BOLD TREE-LIKE
PANEL.

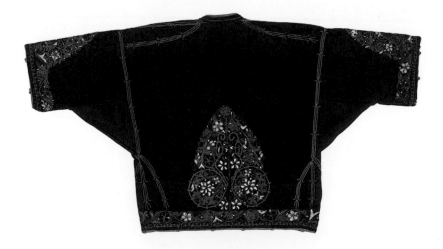

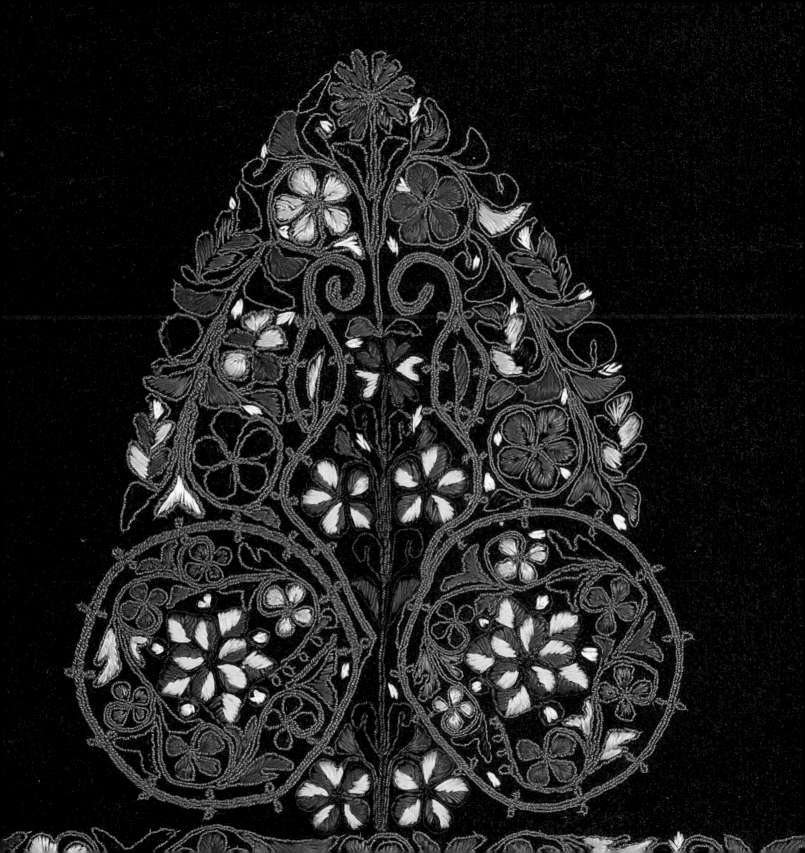

JACKET (*TAQSIREH*)
Bethlehem area, 19th or
early 20th century

The dark blue velvet is
embroidered with gilt-cord
couching filled with satin stitch.
The simple wreath pattern is also
found on the side and sleeve
panels of *malak* dresses
from the same period.
48 × 78 cm (19 × 30 3/4 in)

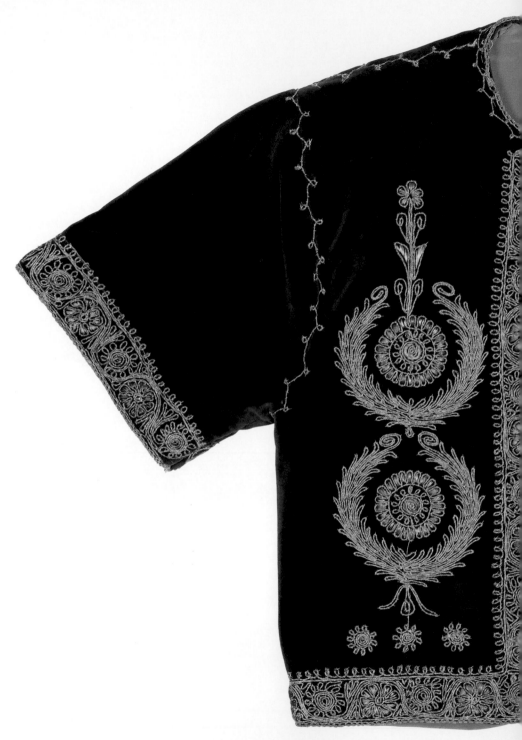

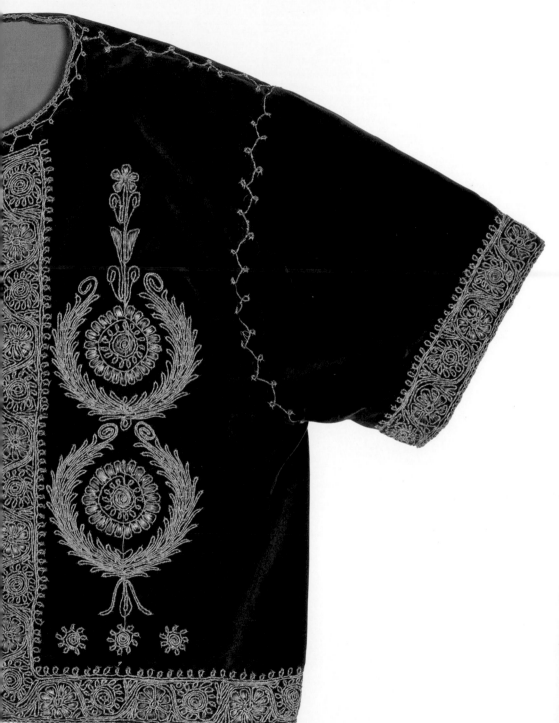

VELVET ONLY BECAME WIDESPREAD FROM THE 1930S, SO WAS A GREAT LUXURY AT THIS EARLY PERIOD. IT PROVIDES A PERFECT BACKGROUND FOR THE LUXURIOUS YET RESTRAINED COUCHING.

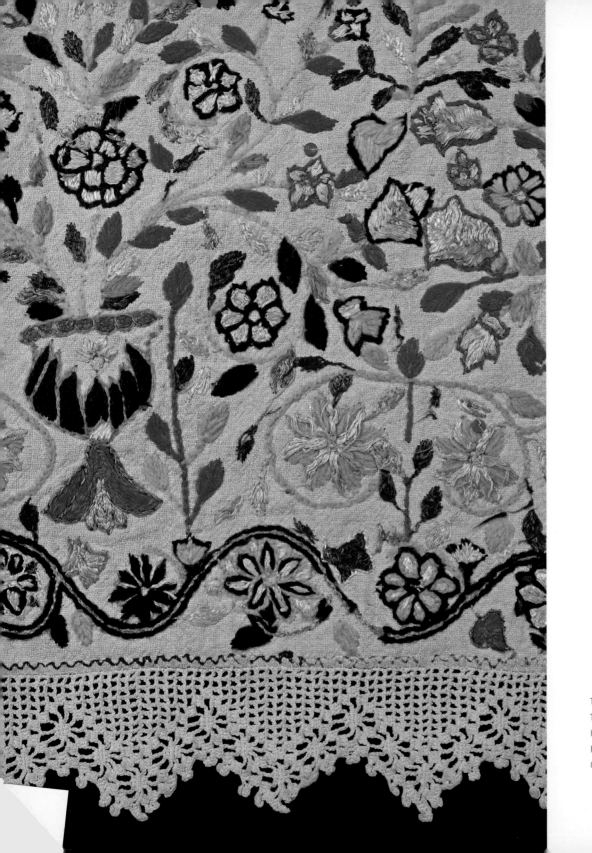

VEIL (*KHIRQAH*)
Bethlehem, 19th or early
20th century

This veil of fine natural linen is
embroidered in silk and wool in a
variety of stitches. It is bordered
with lace of European origin.
168 × 83 cm (66 × 32 1/2 in)

THE FLORAL AND CURVILINEAR MOTIFS
TYPICAL OF BETHLEHEM EMBROIDERY ARE
HERE EMPLOYED IN A MORE FREE-
FLOWING, EXUBERANT MANNER THAN ON
OTHER GARMENTS.

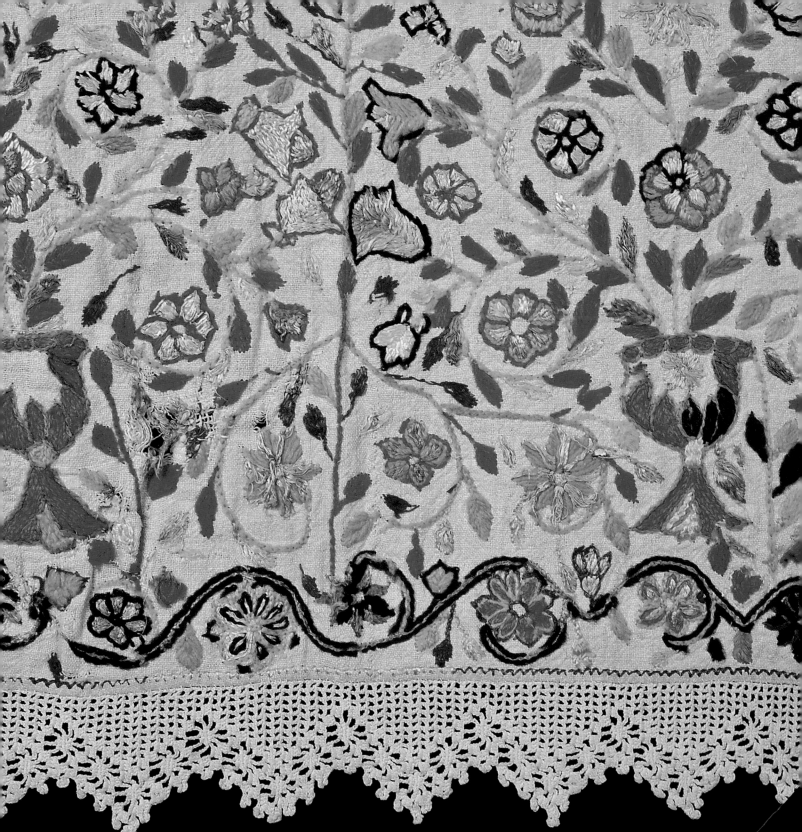

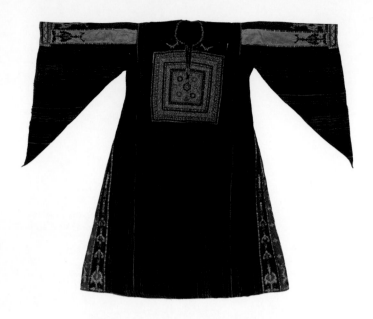

DRESS (*THOB MALAK*)
Bethlehem area, late 19th or early 20th century

The dress takes its name (which means 'royal
dress') from the expensive striped linen and silk
fabric which was woven locally. The taffeta
(*heremzi*) panels inserted and applied on the
sleeves, side skirt panels and chest square are
couched in silk and metallic cord filled with satin,
herringbone and satin stitches in floss silk.
133 × 146 cm (52¹/₂ × 57¹/₂ in)

THIS DRESS COMBINES SEVERAL LUXURY
FABRICS OF VARIOUS ORIGINS. ITS MOST
STRIKING FEATURE IS THE CHEST PANEL, WITH
ITS CONTRASTING COLOURS AND ZIGZAG
EDGES. IT IS STRUCTURED IN THE SAME WAY AS
THAT ILLUSTRATED ON PAGES 70–71, BUT THE
EMBROIDERY IS DENSER AND MORE INTRICATE.

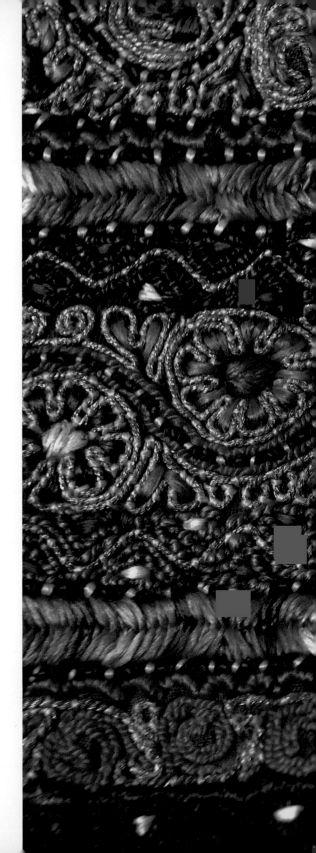

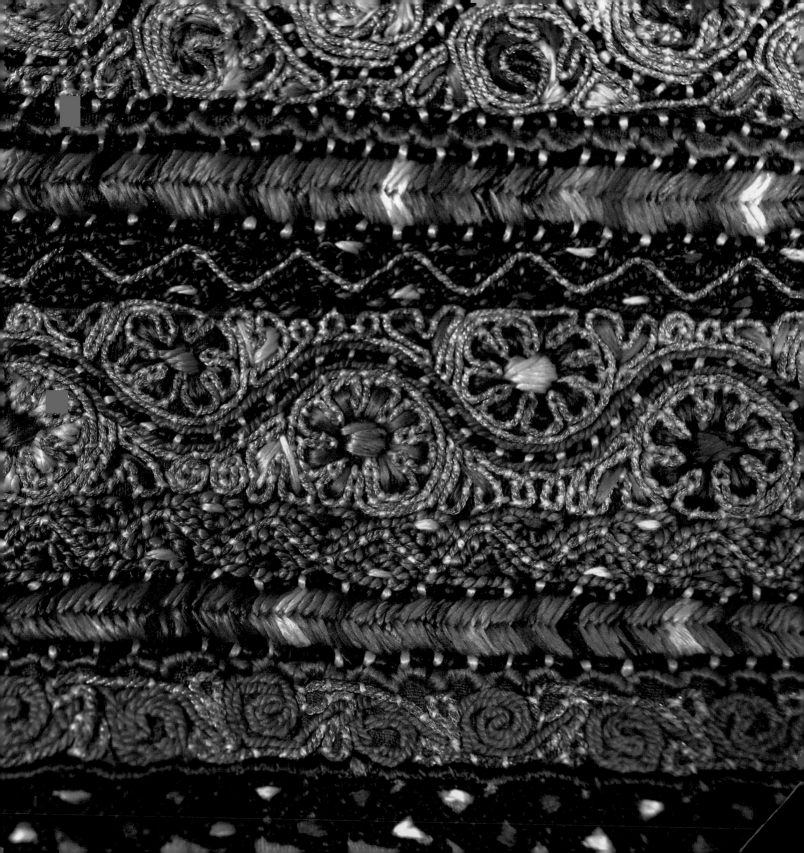

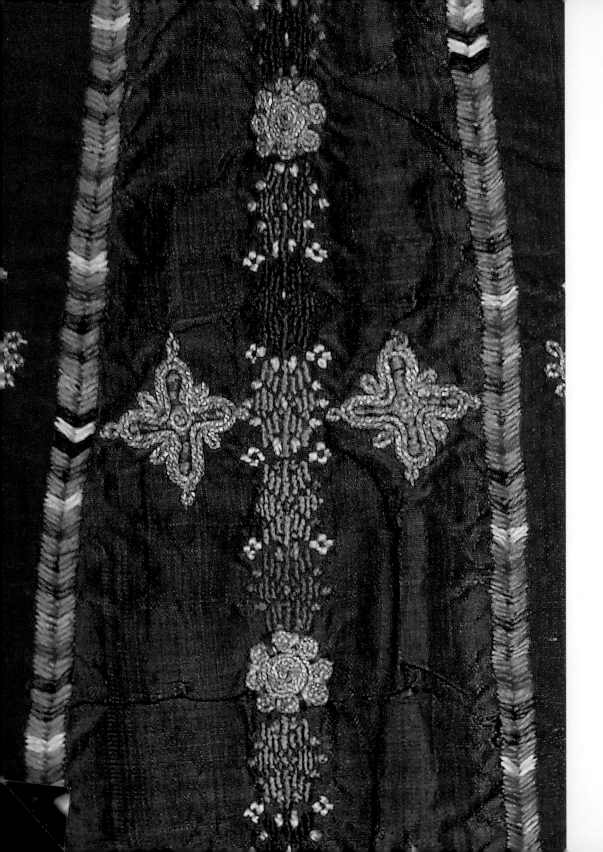

LEFT: DELICATE CROSS-STITCH
MOTIFS ON A TAFFETA SKIRT PANEL
OF THE BETHLEHEM 'ROYAL DRESS'
ILLUSTRATED ON THE PREVIOUS
PAGES.

RIGHT: COUCHING IN SILK AND
METALLIC CORD ON THE TAFFETA
SLEEVE PANELS OF THE SAME
DRESS.

THE TAFFETA PANELS ARE JOINED
BY A FORM OF HERRINGBONE
STITCH IN MANY COLOURS. THE
WREATH MOTIF IS SURMOUNTED
BY A TYPICAL BETHLEHEM BIRD
(SEE COVER).

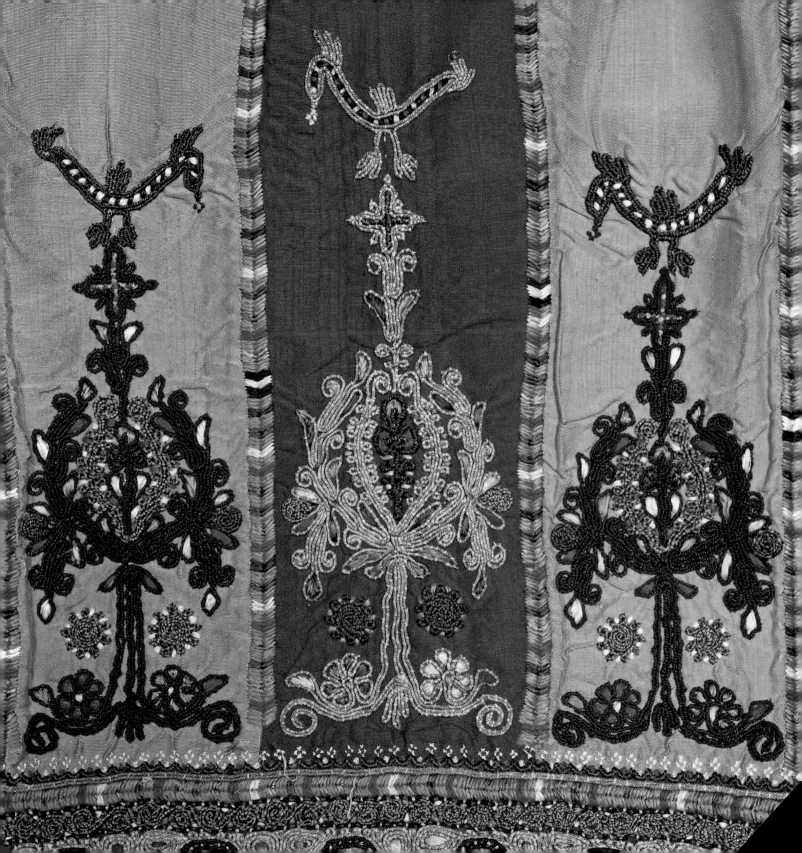

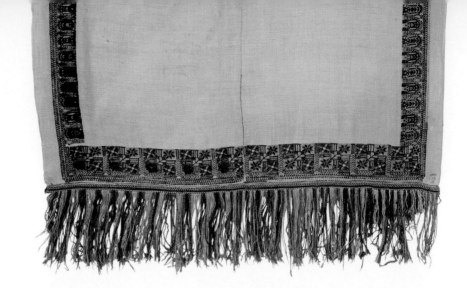

VEIL (*KHIRQAH*)
Bethlehem, 19th century

The cotton veil is embroidered along four sides in stem stitch and broken running stitch. It has a matching multicoloured fringe.
235 × 95 cm (92 1/2 × 37 1/2 in)

THE DELICATE SHADES AND PATTERNS OF THIS FINE VEIL ARE REMINISCENT OF GREEK ISLAND EMBROIDERY.

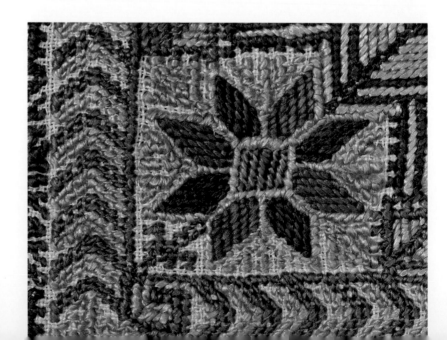

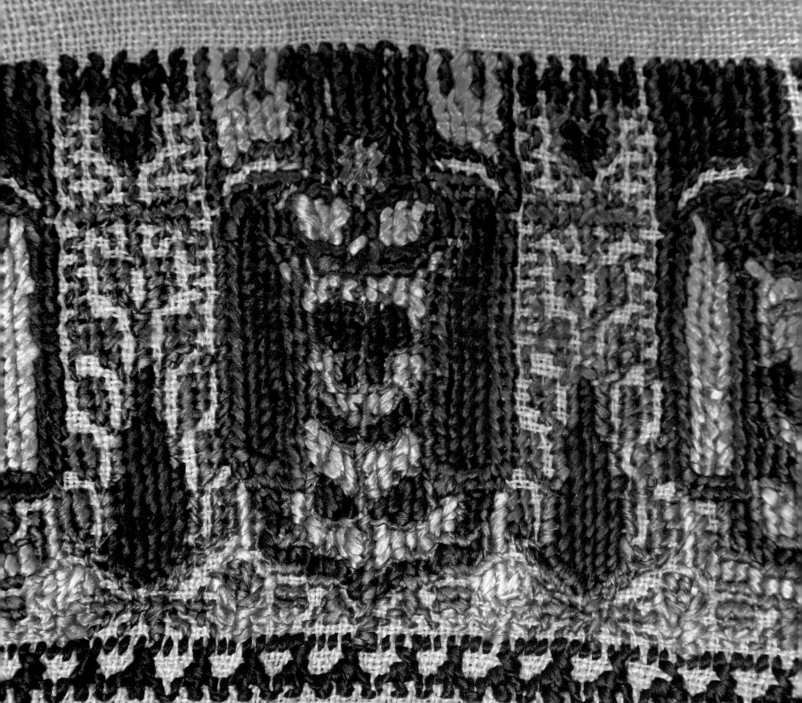

glossary

acrylics yarns and fabrics made from synthetic fibres
aniline dye derived from coal tar; developed commercially
 from the late 19th century
appliqué decorative patchwork sewn onto the main fabric
 of the garment
atlas silk satin fabric made in Syria

broadcloth woven woollen fabric with a felted surface
brocade fabric with floating WEFT patterns

couching patterns made by sewing threads or cords
 onto the fabric

DMC Dolfus Mieg et Cie: French manufacturer of MERCERIZED
 cotton embroidery threads

dura'ah coat

floss silk raw silk threads unwound from the silkworm
 cocoon and sold in skeins; embroiderers combined the
 threads to the required thickness

ghudfeh headveil made from three widths of fabric

heremzi silk taffeta

ikat resist-dyeing technique whereby sections of WARP and/or
 WEFT yarn are bound before dying so that they are not
 coloured; this gives a broken edge to the woven patterns
ikhdari 'green' fabric, and dress thereof; navy blue cotton or
 linen with green and red silk stripes, bordered by narrow
 yellow and red stripes, at the SELVEDGES; formerly woven in
 Mejdel and Bethlehem
indigo blue dye made from the plant *Indigofera tinctoria*;
 formerly cultivated in the Jordan valley, and used by dyers
 in Jerusalem and other Palestinian towns

jihaz wedding trousseau
jillayeh the finest coat or dress that the bride prepared for
 her trousseau
jinneh-u-nar literally 'heaven-and-hell'; narrow white or blue
 fabric with green and red silk stripes at the SELVEDGE;
 formerly woven in Mejdel

kermes an insect-based natural dye which gives shades of
 red, orange and yellow
kermezot ribbed silk fabric
khirqah headveil made from two widths of fabric
kisweh groom's contribution to the wedding trousseau

malak literally 'royal'; fabric with silk warp stripes and rows of
 rosettes, formerly woven in Bethlehem; *thob malak* or
 malakeh – the best dress contributed by the groom to the
 trousseau; commissioned from professional embroiderers
 mainly in the Bethlehem area.
mercerized or **perlé cotton** spun cotton threads
 manufactured with a sheen imitating silk

selvedge side edge of a fabric, where the WEFT returns

taqsireh jacket of broadcloth (earlier) or velvet (later)
thob dress
tishrimeh (*also* **tishrifeh**) zigzag appliqué used for framing
 and edging

warp lengthways threads on the loom and in the finished
 fabric
waste canvas open-weave material attached to the fabric to
 be embroidered to aid patterning; removed thread by
 thread after the embroidery is completed
weft widthways threads on the loom and in the finished fabric

selected reading

Cultural and Historical Background

Amiry, Suad and Vera Tamari, *The Palestinian Village Home,*
London: British Museum Press, 1989.

Dimbleby, Jonathan and Donald McCullin (photographer), *The
Palestinians,* London: Quartet Books, 1979.

Graham-Brown, Sarah, *Palestinians and their Society, 1880-1946:
A Photographic Essay*, London: Quartet Books, 1980.

Granqvist, Hilma, *Marriage Conditions in a Palestinian Village,*
vols I & II, Helsinki: Societas Scientiarum Fennica, 1931 & 1935.
On the village of Artas, south of Bethlehem; includes vivid
descriptions of weddings and wedding costume.

Khalidi, Walid, *Before their Diaspora: A Photographic History of
the Palestinians 1876-1948,* Washington DC: Institute for
Palestine Studies, 1984.

McDowall, David, *The Palestinians*, London: Minority Rights
Group, 1987.

Morris, Benny, *The Birth of the Palestinian Refugee Problem,
1947-49*, Cambridge: Cambridge University Press, 1987.
Explains how each Palestinian village was affected by the
violent establishment of the State of Israel.

Seger, Karen, *Portrait of a Palestinian Village: the Photographs of
Hilma Granqvist*, London: Third World Centre for Research and
Publishing, 1981. Shows everyday life in the village of Artas,
south of Bethlehem, in the 1930s and 1940s.

Shaheen, Nabil, *A Pictorial History of Ramallah*, Beirut: Arab
Institute for Research and Publishing, 1992.

Tristram, H.B., *The Land of Israel: a Journal of Travels in Palestine*,
London: SPCK, 1865. Socially observant missionary memoir.

Palestinian Costume and Embroidery

Amir, Ziva, *Arabesque: Decorative Needlework from the Holy
Land*, New York: Van Nostrand Reinhold, 1977. Includes charts
of cross-stitch motifs.

*Bethlehem Embroidery: The Evolution and Spread of the
Bethlehem-Style Embroidered Chest Panel* (in Hebrew),
Jerusalem: the Israel Museum, 1988.

Crowfoot, Grace, 'Embroidery of Bethlehem', in *Embroidery*,
December 1936.

Crowfoot, Grace and Phyllis Sutton, 'Ramallah embroidery', in
Embroidery, March 1935

Institut du Monde Arabe, *Memoire de Soie: Costumes et Parure
de Palestine et de Jordanie: Catalogue de la Collection Widad
Kamel Kawar*, Paris, 1988. Catalogue of a major private
collection of Palestinian and Jordanian village costumes, with
introductory essays by various scholars.

Kana`n, Sharif et al., *Al-Malabis al-Sha`biyyah al-Falastiniyyah
(Palestinian Folk Costumes)*, El-Bireh: In`ash al-Usrah Welfare
Society, 1982. Includes charts of cross-stitch motifs.

Kawar, Widad, *Costumes Dyed by the Sun: Palestinian Arab
National Costumes,* Tokyo, 1982. Illustrates choice pieces from
the Kawar collection.

Kawar, Widad and Tania Nasir, *Palestinian Embroidery: Traditional
'Fallahi' Cross-Stitch*, Munich: State Museum of Ethnography,
1992. Illustrates many motifs; gives DMC thread-colour
numbers used in different areas.

Rajab, Jehan, *Palestinian Costume*, London: Kegan Paul, 1989.
Illustrates costumes in the Tareq Rajab Museum, Kuwait.

Stillman, Yedida, *Palestinian Costume and Jewelry*,
Albuquerque: University of New Mexico Press. Catalogue
of costumes collected by John Whiting and Widad Kawar
in the Folk Art Museum, Santa Fe; provides an art-
historical, etymological, perspective.

Weir, Shelagh, *Palestinian Embroidery*, London: British Museum
Press, 1970. An exhibition booklet.

— *Spinning and Weaving in Palestine*, London: British Museum
Press, 1970. An exhibition booklet.

— 'A bridal headdress from southern Palestine', in *Palestine
Exploration* Quarterly, 1973. On a headdress worn in the
Hebron Hills, and probably embroidered in Bethlehem.

— *The Bedouin: the Material Culture of the Bedouin of Jordan*,
London: World of Islam Festival Trust, 1976. Published to
accompany the 'Nomad and City' exhibition at the Museum of
Mankind; reprinted 1990 by British Museum Press; includes
section on costumes and embroidery.

— *Palestinian Costume*, London: British Museum Press, 1989
(reprinted 1990; paperback 1994). Illustrates pieces from the
British Museum collection, plus choice pieces from other
collections; text based on field research in Palestine, Israel and
Jordan; describes the language of male and female costume in
its social and ritual context.

— 'Palestinian embroidery', in Harris (ed.), 1993: Chapter 10.

Weir, Shelagh and Widad Kawar, 'Costumes and wedding customs
in Bayt Dajan', in *Palestine Exploration Quarterly*, 1975.

Weir, Shelagh and Serene Shahid, *Palestinian Embroidery: Cross-
Stitch Patterns from the Traditional Costumes of the Village
Women of Palestine*, London: British Museum Press, 1988.
Includes instructions on how to do cross stitch, and to make a
cushion cover.

Wider Comparisons

Baker, Patricia, *Islamic Textiles*, London: British Museum Press, 1995.

Balfour-Paul, Jenny, *Indigo in the Arab World*, Richmond: Curzon Press, 1997. Includes description of the production of indigo-dyed cloth.

— *Indigo*, London: British Museum Press, 1998. Includes illustrations from Palestine and the Middle East.

Ellis, Marianne and Jennifer Wearden, *Ottoman Embroidery*, London: Victoria & Albert Publications, 2001. Includes description of stitches.

Ellis, Marianne and Barbara Rowney, 'Eastern Mediterranean Treasures', in *Treasures from the Embroiderers Guild Collection*, (ed.) Elizabeth Benn, Newton Abbott: David and Charles, 1991.

Harris, Jennifer (ed.), *5000 Years of Textiles*, London: British Museum Press, 1993.

Johnstone, Pauline, *A Guide to Greek Island Embroidery*, London: Victoria & Albert Publications, 1972.

— *Turkish Embroidery*, London: Victoria & Albert Publications, 1985.

Kalter, Johannes, Margareta Pavaloi and Maria Zerrwicke, *The Arts and Crafts of Syria*, 1992.

Papademetriou, Eleni, *Cypriot Ethnography Collections in British Museums*, Nicosia: Ministry of Education and Culture (Cultural Services), 2000.

Taylor, Roderick, *Ottoman Embroidery*, London: Studio Vista, 1993.

museum accession numbers

PAGE	ACC. NO.				
Cover	1967 As2.11				
1	1966 As1.66				
2/3	1970 As14.1				
4/5	1967 As2.11				
7	1981 As18.1 (top)	38	1981 As23.14	61	1971 As10.1
7	1968 As4.18 (right)	40	1981 As23.3	62	1971 As1.1
7	1970 As12.1 (bottom)	43	1970 As14.1	66	1968 As4.18
7	1979 As11.1 (left)	46	1968 As4.31	68	1966 As1.59
24	1966 As1.65	48	1969 As8.10	71	1966 As1.14
29	1966 As1.66	51	1970 As15.2	72	1966 As1.7
30	1966 As1.69	52	1969 As8.5	74	1967 As2.12
32	1968 As5.2	53	1970 As12.1	76	1992 As8.67
33	1968 As12.17	56	1981 As18.1	78	1967 As2.11
34	1967 As2.15	58	1979 As11.1	82	1966 As1.16

publisher's acknowledgements

The textiles featured in this book are drawn from the collections of the British Museum and have been selected from the viewpoint of their design and technical merit.

We should like to express our thanks to the many people who have helped us in the production of this book, and in particular the Museum staff: Helen Wolfe, Imogen Laing and Mike Row.

picture credits

index

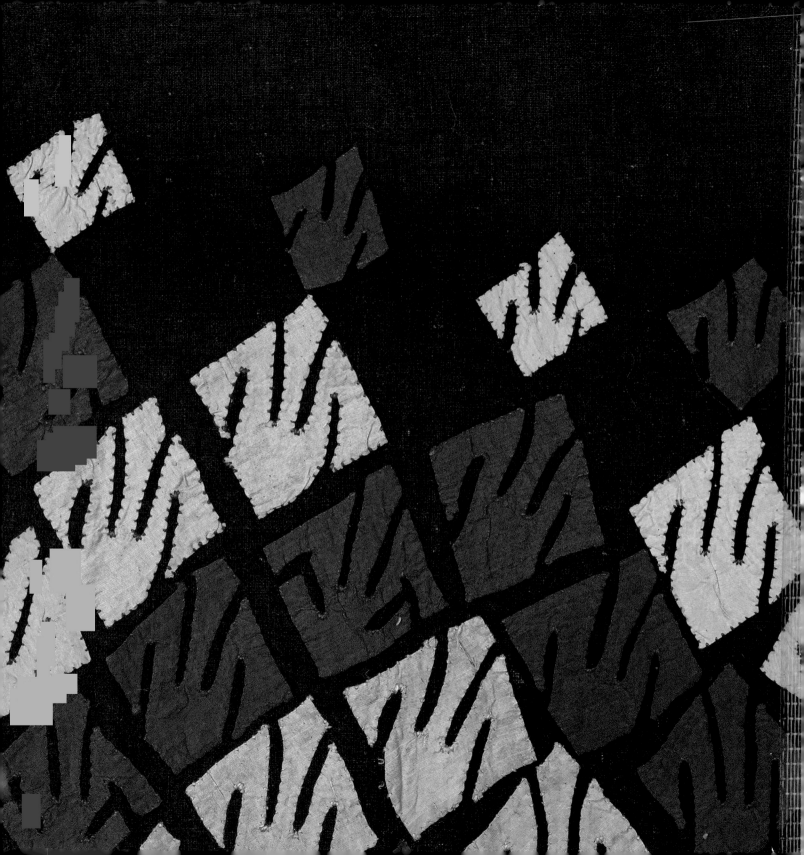